LOUISIANA FACES

LOUISIANA FACES

Images from a Renaissance

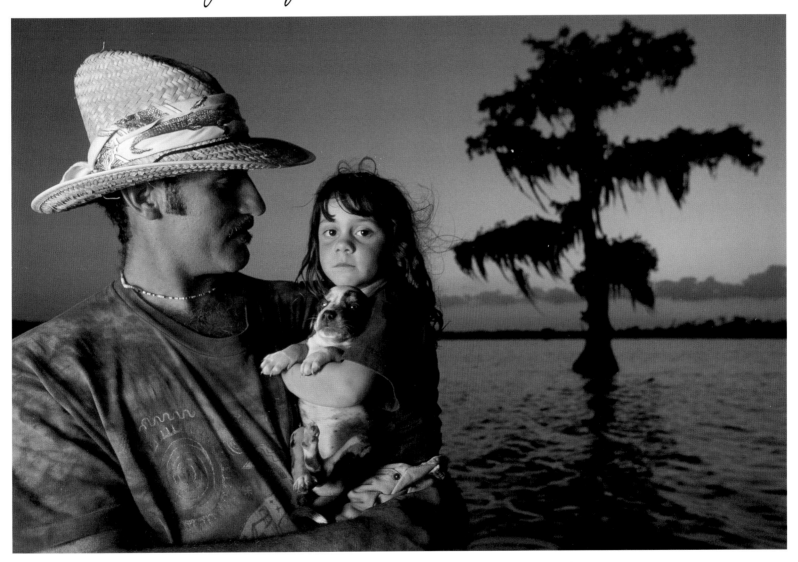

Photographs *by* PHILIP GOULD

Text by JASON BERRY

Louisiana State University Press Baton Rouge MM

Manufactured in Hong Kong
First printing
09 08 07 06 05 04 03 02 01 00
5 4 3 2 1

Designer: Laura Roubique Gleason
Typeface: Minion text with Charlemagne display
Printer and binder: Dai Nippon Printing

Library of Congress Cataloging-in-Publication Data:
Gould, Philip, 1951–
 Louisiana faces : images from a renaissance / photographs by Philip Gould ;
 text by Jason Berry.
 p. cm.
 ISBN 0-8071-2646-2 (cloth ; alk. paper)
 1. Portrait photography—Louisiana. 2. Gould, Philip, 1951– I. Berry, Jason.
 II. Title.
 TR680 .G675 2000
 779'.2'09763—dc21

00-009246

The paper in this book meets the guidelines for permanence and durability
of the Committee on Production Guidelines for Book Longevity of the
Council on Library Resources. ∞

Title page photograph: *1997* Marcus Delahoussaye, a professional swamp
tour guide, holds his daughter Christina and her Catahoula puppy Babaloo
as dusk falls over Lake Martin near Breaux Bridge.

The photograph on page 100 is from Cyril E. Vetter (text) and Philip Gould (photographs),
The Louisiana Houses of A. Hays Town (Baton Rouge: Louisiana State University Press, 1999).

This book is for sons,
 Colin and Daniel Gould

and daughters,
 Ariel and Simonette Berry

with deepest love

RENAISSANCE

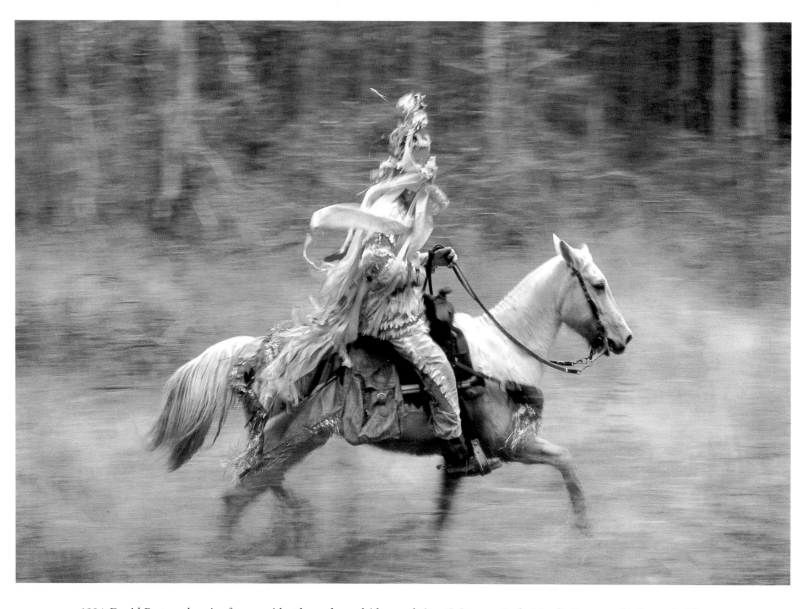

1994 David Bertrand, a rice farmer, rides through roadside woods in a Cajun courir du Mardi Gras near his home in Elton. The courir is a family-and-friends affair with his immediate kin being the hub of the celebration. Bertrand designed his own costume.

IMAGES FROM A RENAISSANCE

Jason Berry

> *In the transparent black waters of the bayous, the indestructible cypress, symbol of silence*
> *and death, stands knee-deep. The sky is everywhere, dominating everything.*
> *How different the sky as one travels from region to region!*
>
> —Henry Miller, The Air-Conditioned Nightmare

Prologue

In an exotic environment, interpreted by a range of writers and musicians and artists, one discovers life as an unfolding narrative, a daily soundtrack, a floating reassemblage of place as region of the mind.

Louisiana Faces is a journey through this cultural territory—the story of a renaissance, in text and images.

Renaissance may seem a quaint term in a nation stuffed with celebrities. With so many people famous-for-being-famous, how do we determine quality? "Renaissance" is so vulnerable to seizure by car salesmen for TV spots, or publicists for the chambers of commerce, as to be robbed of actual meaning—"rebirth, revival, a movement or period of vigorous artistic and intellectual activity." Nevertheless, Louisiana's ferment over the last quarter-century abundantly qualifies as a renaissance.

Philip Gould and I had quite a challenge in balancing a limit of 120 to 130 photographs against the scores of musicians, writers, and artists who reflect the creative landscape as a whole. There was simply no way to feature everyone who deserved to be included—not by a long shot.

Some choices, like Aaron Neville and Anne Rice, were obvious. And so with Ernest Gaines, one of America's foremost novelists and author of two classics: *The Autobiography of Miss Jane Pittman* and *A Lesson before Dying*. Other choices were difficult to make. Historian Stephen Ambrose—an esteemed professor at the University of New Orleans for many years, a biographer of Nixon and Eisenhower, author of such bestsellers as *Undaunted Courage*—might seem a natural. Yet in allocating photo space for writers (much less for musicians, of whom an entire book could be done), we had to narrow the focus. We wanted a gallery of images to suggest the settings and themes of a cultural identity.

Professor Ambrose's admirable body of work did not fit this frame. Neither, for that matter, did the prolific writings of his protégé at UNO, historian Douglas Brinkley. Ambrose and Brinkley are nonetheless major figures in the literary community.

We came to a similar view of the novelist Richard Ford, who won a Pulitzer Prize for *Independence Day* and has a home in New Orleans. Ford's works, probing a psychological arena of fragmented relationships and sexual searchings, are profoundly contemporary yet have only a few remote ties to Louisiana. In contrast, Robert Olen Butler, who taught creative writing at McNeese State in Lake Charles and won a Pulitzer Prize for his collection of short stories *A Good Scent from a Strange Mountain*, about the lives of Vietnamese immigrants here, considers the state a vital component of his work. Choosing one author over another is not a value judgment on the work, rather a reflection of our thematic architecture.

Choosing visual artists was even more difficult. Some share a linkage in motifs influenced by regional architecture, radiant tropical colors, distinctive flora and fauna, a sense of visual rhythms, suggestive of music. Others can't be as easily labeled. New Orleanian Lin Emery, for example, created a three-story piece in Osaka and received Japan's 1997 Award Grand Prix for public sculpture. Yet her work does not have a distinctive style that reflects the local Louisiana culture.

Many Louisiana painters incorporate visible signs of locale and environment in their art. In fact an entire book could be done on how some of these artists have interpreted the beauty of a natural world imperiled by pollution—the theme of elegiac loss.

The text posed its own issues. The sheer number of Louisiana writers was such that to mention them all became problematic. Moreover, the literary geography includes several authors who no longer live in the state yet whose words spring from a map of memories they carry. Although some of these writers are discussed in the text, they are not among those photographed. In the final measure, we focused on artists whose works we knew well, whose output best registered, for us, a sense of the culture as a whole.

A good many of those who appear in these pages are not artists or musicians, but everyday people whose moments in the lens convey nuances of a social fabric, rhythms of daily life that rise to their own level of art and inspire others with quotidian joys, a precious sense of time and rootedness. In the photograph below, the people eating seafood at the kitchen table, a painting of a prayerful elder on the wall behind them, suggest a familial culture akin to that of the rough-hewn Cajuns about whom Tim

Gautreaux writes, with tenderness yet hard emotional precision, in his acclaimed short stories.

Life in these latitudes

Louisiana is a land of stunning vistas. The lush prairies and serene bayou trails, like the riotous flora of marshes and swamp, open into human terrain of a different beauty—the music, dancing, and costumes; the rites of community and the premium placed on food. Few other places seek such enjoyment of daily life or manifest such indifference to ways of the wider world.

Village, town, and city are marked by festivals, a tradition rooted in seasonal cycles of planting and harvests. Across the heavily Catholic southern parishes a French legacy of Carnival—the winter celebration ushering in the season of Lent—has become the high emblem of a regional identity.

In Cajun country masked men ride horses through the fields

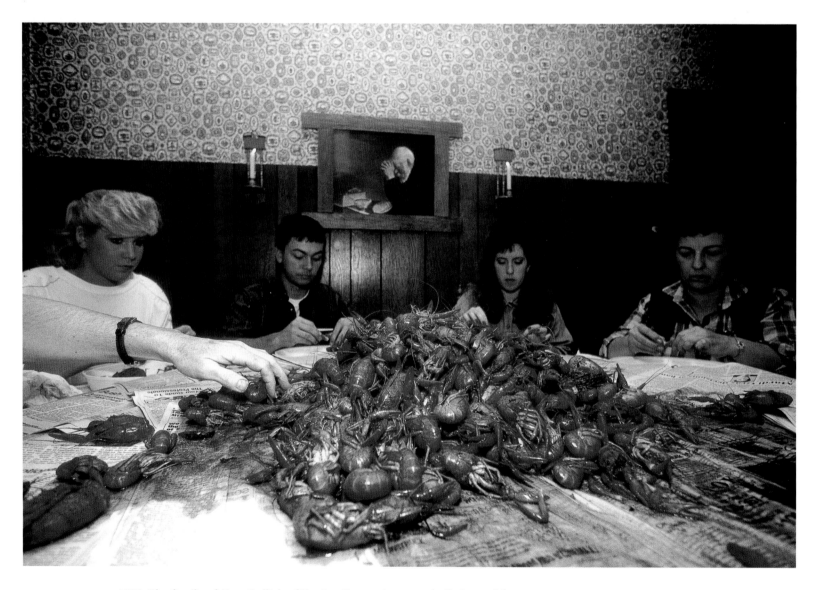

1989 The family of Greg Bollick of Eunice dines at home on boiled crawfish.

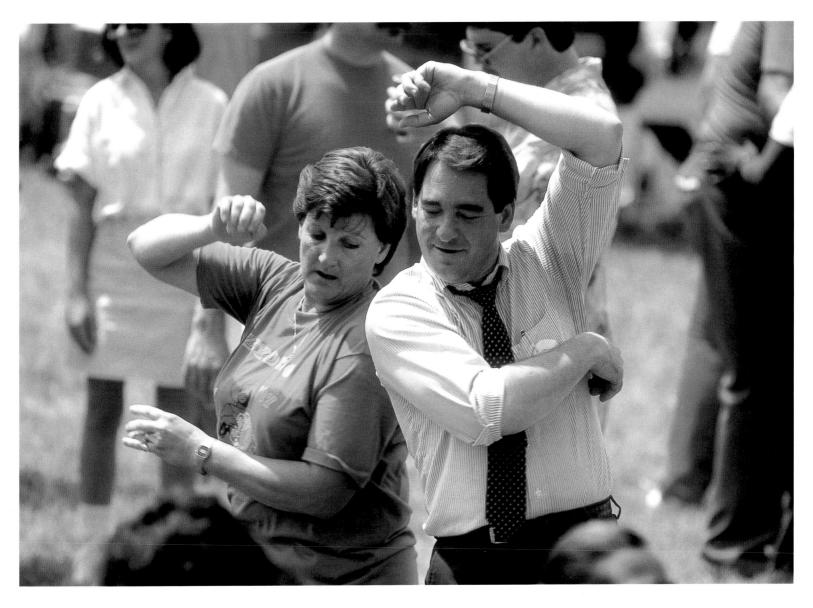

1987 Congressman Billy Tauzin dances with Cajun accordionist Sheryl Cormier at the Zydeco Festival in Plaisance.

and hollows like figures out of *Robin Hood.* A hundred and fifty miles away in the raffish, Babylonian city of New Orleans, parades with lavishly decorated floats, their masked riders tossing beads and doubloons, roll beneath the arched oak limbs of elegant St. Charles Avenue. Bars and clubs across town throb with music as dancing spills into the streets. Such is Mardi Gras, Fat Tuesday, when black men in the Krewe of Zulu, wearing grass skirts, their faces in white greasepaint, dole out gilded coconuts in one of America's stranger forms of satire.

Millions of visitors pour into Louisiana each year, drawn to the dreamy feel of life in these latitudes, charmed by the quirks of an eccentric people. No other southern state markets its excessive behavior with such pride—or lays dubious claim to a parallel drama of epic corruption.

Politicians have an extravagant presence in Louisiana. They barnstorm across the collective imagination, hungry for adulation, in quest of money, promising the sky, insisting on themselves as examples of the rest of us. Sometimes they become exemplars with great zest, as when Governor Earl K. Long stated in 1939: "I am determined to remove from the seat of authority every man who in any degree worships Mammon rather than God."

At the same time, the succession of Louisiana politicians marching into criminal courts has become a spectacle-in-perpetuity, an antiparade of TV news, garish to the good folk returning from festivals, sated with jambalaya and crawfish.

Special-interest check-writers know that candidates, like bantam roosters, need corn in order to strut. Still, why so much

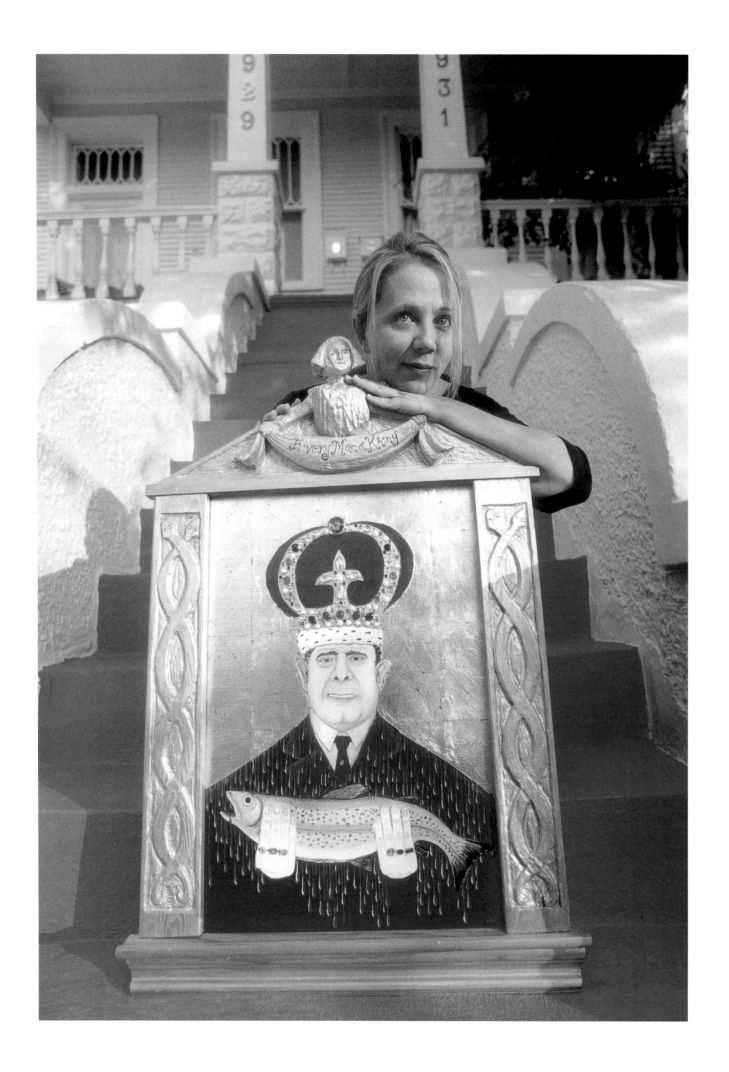

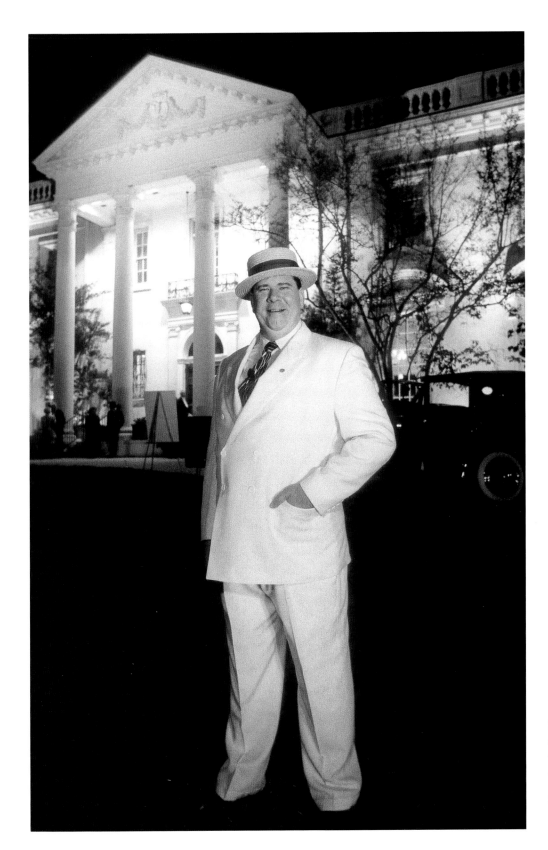

1999 Actor John McConnell poses as Huey Long in front of the old Governor's Mansion on the opening night of the restored building. Long built the mansion as a replica of the nation's White House. Huey is one of McConnell's most popular characters.

1999 Leslie Staub sits with her painting entitled *Kingfish* in front of her house in New Orleans. The portrait of Huey Long is part of a series Staub calls *Icons from the Church of the Soul.*

larceny at the public trough? A former lieutenant governor, Bill Dodd, explained in his memoir, *Peapatch Politics:* "Traditionally, in Louisiana, using political office or political favors to enrich oneself and one's friends has not been swept under the rug; it has been openly advertised. For as long as I can remember, a big-time state politician who failed to get rich and make his friends and relatives rich has been considered stupid."

Huey Long cast himself a populist. He made the Standard Oil Company into a personal punching bag while quietly cutting sweetheart deals with the oil industry to secure leases from mineral-laden state lands for his own enrichment—a mentality that begat endless interpretations by others. Huey's political machine, fueled by extortion from state workers' salaries, crashed after his assassination in 1935. Federal investigators swept in with nets. One prize catch, Gov. Richard Leche, declared in 1939: "When I took the oath of governor I didn't take any vow of poverty." Everyone believed him. He resigned the big house and packed off to a federal penitentiary.

Myriad incarnations of this parasitical spirit have carried down the years. To chronicle them would inflate the book's length and distract us from our focus on the cultural renaissance. But certain images from political life remind us how an artistic culture steals inspiration from the stained banquet of a petrochemical democracy. With gentle irony, Walker Percy once told a university audience about an oilman who bragged to a newspaper that he had never read a novel. Percy mused that while the oilman had no use for him, he, the writer, could sure make use of that oilman.

A tragicomic personality

Louisiana faces the rest of the nation like the classical masks of Greek theater—tragedy and comedy in equipoise. One mask features the downcurled lips of melancholy, the saddened lines of a doleful brow. The other sports the smile of mirth, a patina shrouding the wonder and mysteries of the human comedy.

These masks are also symbols of Mardi Gras, and like opposite faces of the same coin, they suggest Louisiana's tragicomic personality, a schizophrenia writ large across the screens of news and art. One mask grieves over political realities that prolong the poverty and pump the state with pollution and scandals. That other sports a smile of mirth, a comic sensibility, raising laughter out of pain.

Culturally, Louisiana is one of the richest lands on earth. No other state of comparable size—and certainly none in the South—has produced as many revered musicians, renowned writers, distinguished artists, and influential chefs. There is a texture to the culture, in the faces and settings of the creators, a spiritual topography whose contours our pages seek to cover.

In the 1980s, a fourth generation of New Orleans jazzmen, led by Wynton Marsalis, achieved national renown while the southwest parishes poured out streams of zydeco and Cajun music. The songs flowed into far-flung regions as Louisiana cuisine became a hot trend in such remote environs as San Francisco and Manhattan Island. Meanwhile, the works of novelists, poets, painters, sculptors, photographers, mixed-media artists, actors, and folk artists were sprouting like floribunda in some lost tropical garden.

Pantheon dreams

Every culture has its pantheon, figures of stature whose exploits secure a place in the public psyche—generals, politicians, writers, artists. In a state where power in many minds has become synonymous with corruption, the pantheon of Louisiana is problematic, even a dicey proposition.

Robert Penn Warren's 1947 novel *All the King's Men,* about a demagogue resembling Huey Long, won a Pulitzer Prize. So did Louisiana State University historian T. Harry Williams's 1969 biography of Long, which embraced Warren's interpretation of a Machiavellian character for whom corrupt means justify the ends—in this case, helping to uplift the poor. A later biographer, William Ivy Hair, viewed Huey as darker and more corrupt than Williams's subject. Three feature films have been made about Huey. But no actor has done a better job inside that skin than John McConnell in his bravura performances of *The Kingfish,* a one-man play by Ben Z. Grant and Larry L. King.

McConnell mesmerized audiences in Louisiana and other southern states in the late 1980s, culminating in a critically acclaimed ten-week run in Manhattan. Portly and broad-shouldered, McConnell filled out a white suit with an uncanny resemblance to his subject. From a realm of the afterlife, Huey reminisces: "I ran the state through my hand-picked successor as governor, one Oscar 'O.K.' Allen. . . . Most people claimed he got his name from saying 'O.K.' to everything I told him to do. They told it on old Oscar Allen that he signed so many papers I shoved in front of him that one day, a leaf blew in the window and that boy signed it before I could stop him."

In the spring of 1999, life imitated art when a legislative seat became vacant in Metairie, the suburb of New Orleans where McConnell lives with his wife and children, and the actor entered the race as a Republican.

and Canada," says McConnell, because it lacks a state-of-the-art studio and sophisticated policy to attract and generate productions. "We're also losing talent."

McConnell finished seventh in a field of fourteen; he won praise from his competitors for a gentlemanly campaign—nothing like the tactics Huey used. "Playing a politician," he sighs, "is a big difference from being one."

No one knows that better than Jimmie Davis, who celebrated his 100th birthday in 1999 with a banquet in Baton Rouge to raise funds for a tabernacle in his honor in north Louisiana. Davis was a country-western singer with a hit song, "You Are My Sunshine," when he won the governorship in 1944. As a photo-op he rode a horse into the legislature. Near the end of his term he spent a long stretch in Hollywood, starring in *Louisiana*—a film about his life! In 1960 the man whose music was clearly influenced by the blues made a comeback—running as a segregationist. His second round as governor was marred by racial conflict he handled badly.

In Louisiana, as in Hollywood, celebrity has endless acts as long as you keep showing up. Davis spent the last thirty years performing at gospel jamborees, refurbishing his image as the Sunshine man. He is the only governor elected to the Country Music Hall of Fame, the Nashville Songwriters Hall of Fame, and the Gospel Music Hall of Fame.

John McConnell also played the stage role of Ignatius Reilly, the bumblingly quixotic hero of *A Confederacy of Dunces*, the comic novel set in New Orleans. The 1980 novel won a Pulitzer Prize for its author, John Kennedy Toole, who had committed suicide in 1969. (His mother, with

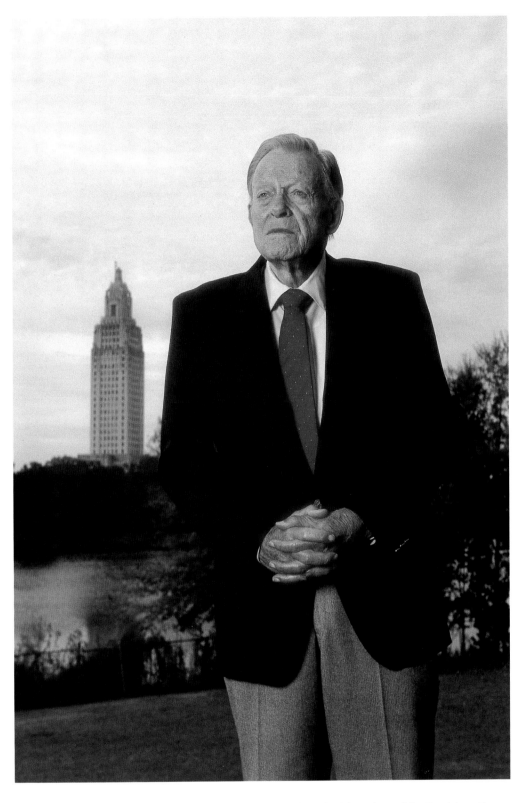

1995 Former governor Jimmie Davis stands in his backyard with a view of the Louisiana State Capitol in Baton Rouge.

He campaigned for termite extermination (termites being a serious recurrent threat to south Louisiana trees and wooden houses), flood protection, and the need to improve the state's film industry. "Louisiana is losing a lot of money to other states,

pivotal help from Walker Percy, had eventually found a publisher for her son's manuscript.)

Artist Leslie Staub's 1995 exhibition *Church of Soul* placed author Toole in her pantheon of Louisiana icons. Staub's figurative

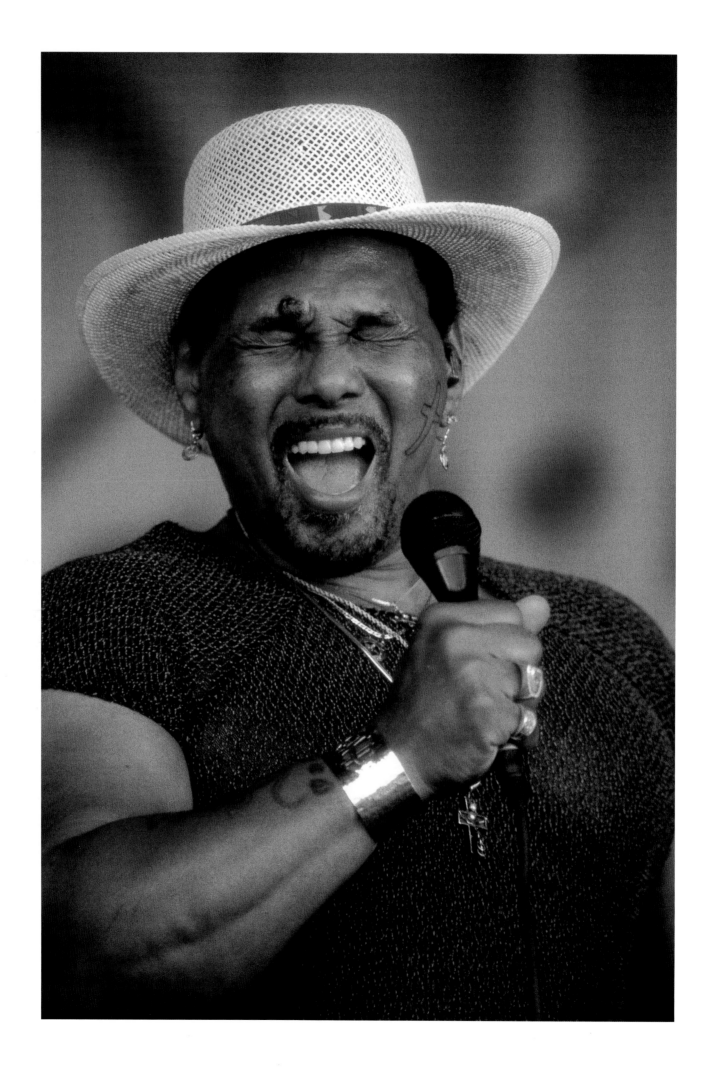

portraits, painted on thick wood, include Huey Longs wearing a crimson crown, suggestive of his slogan "Every Man a King," as he holds a large "cutthroat trout" in both hands. He looks like a happy thief. Staub did pictures of musicians Danny and Blue Lu Barker, Clifton Chenier, Jimmie Davis (with the caption "You Are My Sunshine . . . I am your governor"), Tennessee Williams, and others.

"I wanted to show in some way how cultural experience and spirituality are deeply connected," she explains. "The heroes and anti-heroes of popular culture reflect not only our collective thoughts, but also, to some degree, the state of our souls. My angels and devils are the poets, musicians, writers, and politicians who have moved me. It is they who form the motley pantheon of my personal religion; a pantheon less than saintly perhaps, but no less relevant to me than the gods, goddesses, saints, and sinners of other places, other times."

Douglas Bourgeois, one of the South's most acclaimed and successful painters, works in his hometown of St. Amant. He too uses musical figures in a stylized personal canon. "The bright, dreamy images, which often resemble religious icons, are filled with reminders of Louisiana: coffee, swamps, chemical plants, oil refineries and black musicians," wrote critic John Kemp of his work.

Sources of the culture

Louisiana's renaissance stems from several wellsprings.

Chief among them was the civil rights movement of the 1960s. The black freedom quest that dismantled legal segregation also opened avenues of communication among people who had lived in close proximity for generations yet were barred by fear from mutual understanding. The continuing dialogue is often too slow, saddled with frustration and recriminations on both sides; but the changes have had a profound, beneficial impact on the society.

The outpourings in music, cuisine, and folklife—and to a certain degree in literature as well—have deep roots in family structure and religious worship. The South is the region of America that stands apart by virtue of a collective memory rooted in land, faith, and family—sources that may seem antique to champions of mass culture. In Louisiana, the ritual nature of many literary and artistic works stands as a vast performance of memory, rituals of remembrance in a land of exotica and spectacle at the bottom of America. Much of the popular music has been shaped in churches. The Assemblies of God services influ-

enced the musical destinies of the 1950s rockabilly power Jerry Lee Lewis and his cousins televangelist Jimmy Swaggart and country-western artist Mickey Gilley in the town of Ferriday, in the pentecostal heartlands of central Louisiana, during the 1930s and 1940s. The piano playing and joy-whooping of people caught up in the spirit were a far cry from more solemn services of the mainstream Protestant or Catholic congregations. But church rites of poor folk, white and black, were a shape of things to come.

Down in New Orleans, Aaron Neville, who spent several of his early years in the Calliope Street housing project in central city, was a Catholic influenced by black gospel harmonies. Brass bands have played in small, vernacular churches in New Orleans since the 1920s, if not earlier. Gospel was a shaping influence on

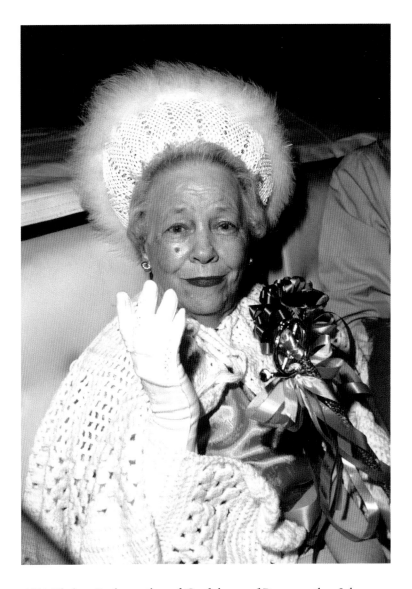

1981 Thelma Toole, mother of *Confederacy of Dunces* author John Kennedy Toole, waves in a Christmas parade in New Orleans.

1997 Aaron Neville belts out a song during a Neville Brothers set that closed out the New Orleans Jazz and Heritage Festival.

the great blues singer Johnny Adams, who passed away in 1998; on rhythm-and-bluesman Ernie K-Doe; on blues diva Irma Thomas; on the grand Marva Wright, who came up in a Full Gospel choir; and on the rising star Davell Crawford—grandson of the great Sugarboy Crawford—an artist who still sings in church and includes gospel songs in many club gigs.

Aaron Neville's career as a soloist soared in the 1980s, thanks in part to a series of recordings with Linda Ronstadt for which he won a Grammy. He still performs regularly with his brothers. The tenderness that rises in Aaron's gorgeous falsetto reach stems from a spirituality that seems incongruous with the burly frame and that menacing dagger tattooed on his cheek. "Some people think I look thuggish," he reflected in a 1979 interview. "But looks can be deceiving." In the early years of his career, he worked as a longshoreman on the Mississippi River docks to support his family. Later he struggled with a drug addiction that led him to make novenas to St. Jude, the patron of hopeless cases, at the shrine of the Our Lady of Guadalupe Church on Rampart Street. He has made recordings to benefit social and religious causes. He wears a St. Jude medallion as an earring.

One day Aaron entered the St. Jude shrine with a TV producer who had grown up a Protestant in the Mississippi Delta. As the producer gazed at the masses of people, Neville pointed to the marble: "You got to kneel for Jude." The producer got down on his knees.

No individual artist can be reduced to a sum of influences; but churchsong was a seminal force in the lives of Louisiana musicians too numerous to mention. They came up in families for whom church was central to their lives and carried memories of the music with them. The same holds for many, perhaps the good majority, of young jazzmen and pop singers who have emerged from these parts since 1980.

Another, perhaps overarching, factor in Louisiana's renaissance has been the emergence of New Orleans as an international city. With a multibillion-dollar tourist economy, the city has become known as much for jazz and artistic wealth as for the "Big Easy" persona of a rocking party town. New Orleans is also the North American city with the deepest African identity, a characterization made not merely because of a 62 percent black majority. Other cities with black majorities lack the range of music, literary talent, and folk art that are so integral to the cradle of jazz. And yet it is also, in the words of the novelist Louis Edwards, a "break your heart town" because of crime-scarred back streets and the deep poverty in which roughly a third of the city's population is mired.

The late Tom Dent, who wrote about the legacy of the civil rights movement in an autobiographical narrative, *Southern Journey,* was also a poet. Many of his poems dealt with poor people and the city. From "Magnolia Street":

> & your cousins & your aunts & your nieces
> they all came to yr
> wedding, yr hospital bed, yr fund-
> raising Saturday night fish fry
> which was old wood meeting old wood meeting
> old unpainted wood
> which is the truth
> is it not

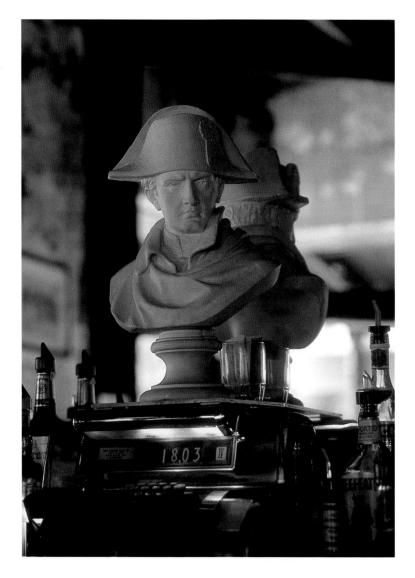

1990 A bar tab at the Napoleon House in New Orleans marks the date of the Louisiana Purchase. Legend has it that around 1820, former mayor Nicolas Girod, who owned the building, joined a conspiracy to rescue Napoleon from exile and bring him to New Orleans. Jean Lafitte was also allegedly in on the plot, which fizzled out with news of the former emperor's death in 1821.

Miss Lucas
& the smell of the acrid tar in the summer
in the street told you it was hot hot
 & i remember your sweating face & your heavy hand
 wiping the sweat

that old winding street
which was yr home
is gone now
Miss Lucas

A crossroads of humanity

Long before *multiculture* became an academic buzzword or *melting pot* a term of sociology, a range of ethnic peoples settled around the eighteenth-century port of la Nouvelle-Orléans. In a melting pot, differences dissolve into an all-American consistency. Multiculture suggests a kind of atomized diversity. New Orleans—and much of Louisiana—is a study in creolization, a process in which new expressions and traditions emerge from a mixture of cultures, with an underlying flavor of the old. The French had a phrase, *un metissage culturel,* or "mingling of bloodlines," that still applies to the Crescent City.

The explorer Bienville founded New Orleans in 1718 for the French crown; Canadian backwoodsmen came down the continent as yeoman settlers and found beds with Indian women; African slaves fostered ties with the Indians as well. Prostitutes and thieves were shipped over from Paris; the port lagged as the plantation economy limped along. In 1762, France ceded control of the colony to Spain, under whose authorities many of the buildings in the French Quarter went up. Spain eventually returned the colony to the French, and in 1803 Napoleon sold the package to the United States with the Louisiana Purchase to pay off his war debts and tweak the British. It was the most important land transaction in American history.

The late Marcus Christian, historian and poet of the black Creole culture, rhapsodized the urban identity in "I Am New Orleans," a 1968 poem on the 250th anniversary of the city's founding:

 I am America epitomized:
 A blending of everything—
 Latin, Nordic and Negro,
 Indian, European and American . . .

 Out of the swamps of Louisiana,
 Out of the blue mud and sand of the Delta,
 Out of hurricanes, storms and crevasses,

1999 An angel painted on plywood hangs under a roadside sign between Sunset and Grand Coteau.

 Out of Indian massacres and slave insurrections;
 Phoenix-like have I risen;
 Out of French, Spanish, and American dominations,
 I have preserved my soul . . .

Out of this soul came creolization, a mixture of ethnic traditions—reassembling shards of the old with materials of the new. At Congo Square, the antebellum commons on Rampart Street, now contained by Louis Armstrong Park, slaves in costumes danced to African rhythms. Indians, free people of color, and white gentry gazed at the spectacle. Congo Square was a taproot of early jazz, the African improvisational genius marching into European instrumentation and melody. These days, when black men dressed as Indians parade through streets during Carnival

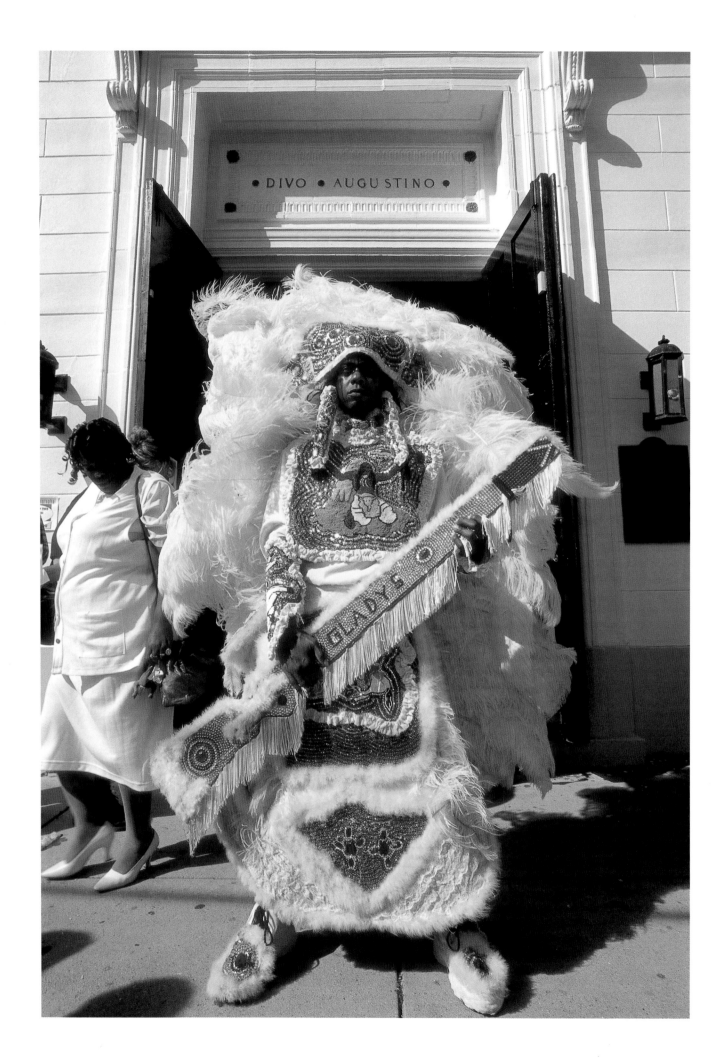

or when brass bands lead gyrating street dancers in jazz funerals, the spirit of Congo Square lives on.

Creolization was a long process, melding strands of culture out of many traditions that converged at this crossroads of humanity.

A powerful river of music and folklore surged through the 1970s and 1980s, and drew sustenance from several institutions:

- Since it began in 1969, the New Orleans Jazz and Heritage Festival has been a catalytic force—rejuvenating careers of older musicians, showcasing younger artists, pushing a tiny network of clubs into a nightclub economy, driving the expansion of an emergent recording and entertainment industry, and for two weeks each spring, drawing focus from international music media on the sounds and culture of New Orleans and south Louisiana.

 The jazz festival's arrangement of tents and booths presenting folk art, crafts, and regional cuisine enlarged the idea of heritage, the definition of culture, as a kind of epic tableau, served up for tens of thousands of people as a vast spring rite. The human topography at the festival revealed an almost mythical diversity—Cajuns and Indians, white rockers and gospel shouters, tents with displays of altars from Spiritual Churches, carvings, metal works, figurative paintings on doors and window jambs, duck decoys, plus so many people eating all that food.

- The launching of the New Orleans Center for the Creative Arts in the late 1970s provided a public school for artistically gifted students. NOCCA hired the pianist Ellis Marsalis to direct the jazz program—today he has an endowed chair at UNO as director of jazz studies. Within a decade of its founding, NOCCA had a roster of stellar jazz alumni. Wynton and Branford Marsalis, singer Harry Connick Jr., trumpeters Nicholas Payton (himself the son of a popular bass player, Walter Payton), Marlon Jordan, and Terence Blanchard, and saxophonist Donald Harrison Jr. studied under the patriarch Ellis Marsalis. Most of the "young lions" moved to New York, the center of gravity in the jazz world, to launch their recording careers; Blanchard, Harrison, and Payton spend much of their time in New Orleans these days.

- In 1977 the Contemporary Arts Center, located in a massive warehouse donated by Sidney Besthoff of the K&B drugstore

chain, became a showcase for artists, with theater and performance space as well. As the largest alternative arts space in the country, the CAC drew large crowds to a warehouse district where art galleries began mushrooming. According to a 1992 study by the University of New Orleans, galleries, museums, and nonprofit art centers had an annual impact of $687.2 million on the local economy.

In 1992 the city had 80 art galleries; by 1999, the number had jumped to 125, according to the *Times-Picayune* art critic Douglas MacCash. John Bullard, the director of the New Orleans Museum of Art, told MacCash that the city's art commerce is the largest in the South, a remarkable phenomenon in light of the staggering growth of metropolitan Atlanta. Yet New Orleans, a city with a population of 450,000—and a greater metropolitan area of 1.2 million residents—is a booming art market, and the third most important in America, behind the much larger cities of New York and Los Angeles. Dozens of working artists in the area provide works for the mushrooming gallery circuit that now exhibits artists from across the country.

The CAC, Jazzfest, and NOCCA were catalysts in the city's cultural life, providing a valuable institutional floor that had simply never existed before.

- The Louisiana Endowment for the Humanities has also played a pivotal role, with a solid grants program for documentaries, historical books, conferences, summer training institutes for teachers, and an ambitious adult literacy program. Louisiana is one of the poorest states in per capita income; yet the LEH has garnered support from corporations and, in recent years, the legislature and Governor Mike Foster. The LEH also publishes an award-winning magazine, *Louisiana Cultural Vistas,* that features the works of many artists and writers. The state Division of the Arts and the arts councils of the major cities provide timely support as well.

 Most of the artists and writers discussed in this book have received grant support in some phase of their careers; some continue to rely on foundation or government aid for various projects. Louisiana's cultural growth is an example of how government funds strengthen careers and the overall economy.

Connective tissues

In the 1970s, the city and its folkways became a theme in music lyrics and visual arts. Bruce Brice, a figurative artist who worked with bright primary colors, painted scenes of Tremé, the neighborhood surrounding Louis Armstrong Park and one of the

1998 Irving Bannister of the Creole Wild West Mardi Gras Indian tribe shows his respects in ceremonial finery at St. Augustine Catholic Church in the Tremé neighborhood of New Orleans. Bannister was attending the funeral of Donald Harrison Sr., chief of the Guardians of the Flame Indian tribe.

oldest African American urban enclaves—scenes of funerals, churches, parades, and street life. The Jazz Festival commissioned posters by various artists, most of which became collector's items. The 1977 poster, by Kathleen Joffrion, featured a traditional jazz ensemble, seated, dressed to the nines, set against palm trees and yellow clouds beneath a blue sky with crescent moon. Two previous posters featured interpretations of the tuxedoed grand marshal who leads brass band parades. (The most illustrious grand marshal at the time was Matthew "Fats" Houston, a walking icon of the tradition. Fats Houston marched for many years with the Eureka and Olympia Brass Bands until his own departure, with a brass band sendoff.) Subsequent posters, especially those by Richard Thomas, extend this tradition.

Museums and galleries began discovering folk artists. Several became nationally known. Sister Gertrude Morgan, a sidewalk preacher in the French Quarter, considered herself a bride of Christ and dressed in white gowns. Inspired by the Book of Revelations, she painted mystical, sometimes apocalyptic, scenes on paper, cardboard, plastic, window shades, a guitar case, fans, even a megaphone—works that long after her death sell for substantial sums.

David Butler was a rural artist, likewise divinely inspired, who created dazzling decorative work—mermaids, trains, flying elephants, religious objects. Herbert Singleton of New Orleans carves stools and walking sticks from tree branches collected along the levee. Upstate, in Ruston, Sarah Albritton has created an extraordinary body of narrative paintings that follow her life from deep poverty, surrounded by racial violence ("I grew up in hell," she has said), through hard work to a vision of breathtaking redemptive promise—angels hover as earth and heaven meet. Over the years Albritton has also, with her husband, run a popular restaurant, Sarah's Kitchen, which adjoins her home. At Christmas she affixes lights to figures that depict the life of Jesus. In 1996 she used more than 200,000 Christmas lights.

The poster art of New Orleans treated spiritual topics of a more raucous realm. Those celebrating black Indians of Mardi Gras became a visual analog to the rise of the Neville Brothers—Art, Charles, Aaron, and Cyril, a line of strapping siblings with rolling, four-part harmonies—who performed with the Wild Tchoupitoulas, a black Indian gang from Carnival, led by the brothers' uncle, Big Chief Jolley (George Landry.) The Nevilles sang lyrics drawn from street chants of the Indians, like "hey pocky-way" and "jockamo feena hey," phrases whose linguistic meanings, buried in old Creole, have been lost with time.

Photographers like Michael Smith and Syndey Byrd, along with documentarians like Les Blank, Andy Koelker, Louis

Alvarez, Paul Stekler, and Stevenson Palfi, trained their lenses on the music, politics, and folk culture.

New Orleans through the 1970s experienced a second flowering of rhythm-and-blues. The city is synonymous with jazz; however, as Langdon Winner of *Rolling Stone* has written, New Orleans "has given us the oldest, richest, and most influential continuing tradition of rock-and-roll playing the music has ever seen."

Pieces of a rich oral tradition bubbled up in songs and performances, floating toward a larger, longer narrative.

There was the galvanizing presence of Professor Longhair (Henry Roeland Byrd), the grand old man of rhythm-and-blues who played piano with a rolling fusion of boogie blues, rhumba, and Cubano licks. Fess—as he was known to many—sang songs like "Big Chief," which celebrated the Mardi Gras Indians ("me

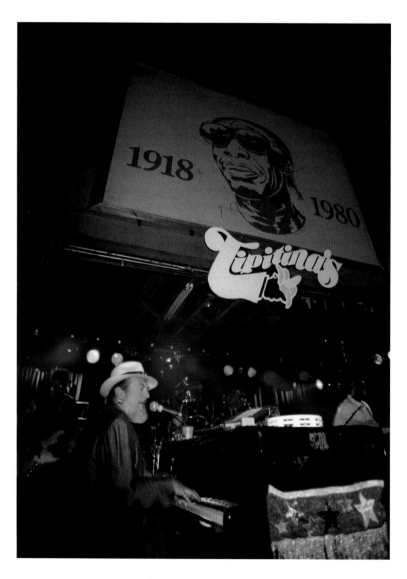

1999 Dr. John plays under the watchful gaze of New Orleans pianist Professor Longhair at Tipitina's in uptown New Orleans.

1999 Sarah Albritton, at her restaurant in Ruston, stands next to one of her paintings depicting a rural black community.

out loaded," the song came to mirror Booker, a bizarre, comic, sadly prodigious talent who made beautiful music while stalked by drug demons that finally destroyed him when he sat down in the waiting room of Charity Hospital one night in 1983 and expired at the age of forty-four.

Burn, K-Doe, burn!

"All you Charity Hospital babies . . . I am calling you!"

So came the riptide perorations of rhythm-and-bluesman Ernie K-Doe as a sometime deejay on WWOZ, the community radio station. "Burn, K-Doe, burn!" he'd exclaim. "A Charity Hospital baby!

"Some people say, K-Doe, why do you talk about Charity Hospital? Because on the second month, twenty-second day of 1936, a boy child was born. Charity Hospital went to rumbling and a grumbling . . . and the doctors say, 'What's wrong? What's happenin'?' They told 'em: 'A boy child been born on the third floor.' . . . I'm a Charity Hospital baby. I'm cocky but God *knows* I'm good!"

big chief me gottum tribe . . . got my Spy Boy by my side"); his anthem "Go to the Mardi Gras" memorialized the corner of Rampart and Dumaine, where the singer waits to see the Zulu Queen, and where, in reality, the small J&M record shop, operated by Cosimo Matassa in the 1950s, had a backroom studio where Fats Domino, Little Richard, Dr. John, Irma Thomas, Benny Spellman, Chris Kenner, and dozens of other musicians made recordings and launched careers.

Fess's lyrics were part of a musical language *about the city,* a vocabulary of place-names and events that carry from one artist to another. The music club Tipitina's, which opened in 1977 at the corner of Napoleon Avenue and Tchoupitoulas Street, was named after a signature Professor Longhair song, a paean to some mysterious girlfriend, "you're three times seven, girl, know what you wanna do." He died in his sleep in the early weeks of 1980. Five thousand people followed two brass bands at his funeral, which was one of the most chaotic and exciting of the many jazz burials the city has seen. Tipitina's and the banner of Fess that hangs above the stage became cultural landmarks.

The percussive keyboard style, laced with blues and roaming rhythms, had a brilliant innovator in James Booker, the self-styled "piano prince" who experimented endlessly with a tune Fess made famous, "Junko Partner." Drawn from folklore at the state penitentiary in Angola about a battered junky, "knocked

K-Doe's stream-of-consciousness riffs about his nativity at the big hospital Huey Long built during the depression were punctuated with the cry emblazoned on t-shirts he now sells at his nightclub: *Burn, K-Doe, Burn!* K-Doe had several hits in the 1960s, including "Mother in Law" and "A Certain Girl." A flamboyant stage presence even by local standards, he advanced an offbeat, outsized, wisecracking soundtrack to the city's madcap ways. In K-Doe one hears an intimation, if not an echo, of Jones, the black man behind sunglasses in John Kennedy Toole's novel *A Confederacy of Dunces.* Though not identified as a Charity Hospital baby, Jones lives the part, as when, seeking a job, he tells the lady owner of a French Quarter bar, "I thought the Night of Joy like to help somebody become a member of the community, help keep a poor color boy outta jail. I keep the picket off, give the Night of Joy a good civil right ratin."

Jones was a satirical character spun of the turbulent sixties. K-Doe, a self-invented celebrity across the decades since, gave us one of the most famous sentences ever uttered about the Queen City: "I'm not sure, but I'm almost positive, that all music came from New Orleans."

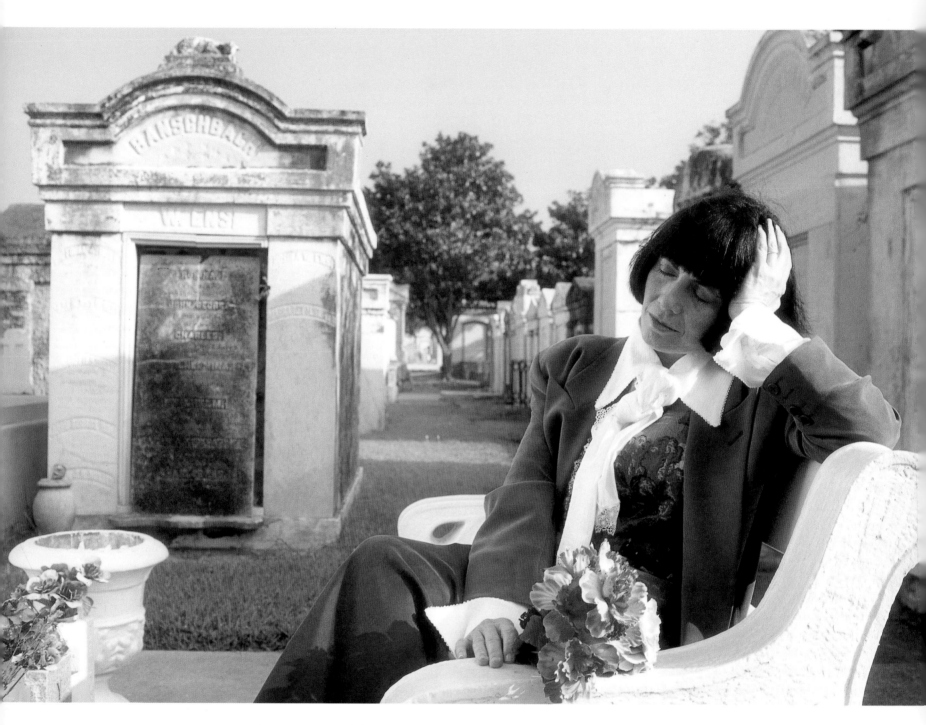

1993 Anne Rice listens to voices of the dead in Lafayette Cemetery in New Orleans.

Brass bands redux

In the early 1980s an emerging generation of New Orleans musicians revitalized the brass band tradition. Some, like the trumpeter Gregg Stafford, leader of the Young Tuxedo Brass Band, and his sidekick, clarinetist Michael White, refined a repertoire of standards like the dirge "Just a Closer Walk with Thee" and older ensemble tunes like "Saint James Infirmary" that had come down across a century of street funerals and dance-hall gigs.

At the same time, the Dirty Dozen Brass Band advanced a more impressionist sound, building on the parade beat of second-liners—street dancers who engulf the band—with faster tempos and improvisational overlays of bebop. By the late eighties, younger brass bands with names like ReBirth were exploring more eclectic rhythms, ranging even farther from the traditional sounds of brass band jazz.

Looziana writers attacking bluebloods!

The moral force of literature distinguishes a culture, registering the tones and complexities of society with subtler streams of a collective unconscious.

In the 1870s and 1880s, George Washington Cable examined the city's patrician society in *Old Creole Days* and *The Grandissimes.* In one story he wrote of a building in the French Quarter: "with gray stucco peeling off in broad patches, it has a solemn look of gentility in rags"—a metaphorical take on the insular culture of French Creoles, losing power to northerners and new wealth. Cable also wrote of the multiethnic society, with inspired treatments of Congo Square and the songs of slaves. Cable was the South's first modern novelist; he charted thematic contours many writers still explore.

Comminglings of class and race pervade the literature of New Orleans. Although Anne Rice's stature stems from the vampire novels, one of her best books, *Feast of All Saints* (1979), is an antebellum tale of the colored Creole caste and a young male protagonist caught between worlds of white and black. The invention of photography allows him to find freedom. "And the small universe around him was his to capture, his to fix and frame at the perfect instant in light and shadow exactly as he perceived it: the shabby grandeur of the old city, faces of all nations, ragged trees, the ever-drifting clouds—this time and place as it had shaped his childhood and the man he had become."

For his writings, Cable was ostracized locally, and eventually moved to Massachusetts. Kate Chopin drew her own bead on a gentry whose males sired shadow children by dark mistresses. Her famous novel *The Awakening* prefigured the women's movement in the fierce search for freedom by its protagonist, Edna Pontellier. Chopin's pejorative view of patrician society and of the constraints on women in the late nineteenth century enraged critics, who savaged the book. Only later was it resurrected by scholars and accorded the high status it justly deserves.

The critique of aristocracy that Cable and Chopin set in motion is a train that keeps on rolling. If southern literature betrays an obsession with aristocracy as a troubled species of the human experiment, nowhere is the battering of bluebloods more relentless than in the works of Louisiana authors.

Detective novels by such authors as Tony Dunbar, Chris Wiltz, Julie Smith, and James Lee Burke find prominent Orleanians engaging in criminal acts. In Dunbar's mysteries the crime solver is Tubby Dubonnet, a lawyer who married well but lost a wife and social pedigree by lots of drinking.

In Robert Penn Warren's *All the King's Men,* an aristocrat's daughter falls in love with the political dictator Willie Stark. Stark is finally murdered by her brother, a doctor—symbolically, a corrupted old society meting out raw justice on the power-lusting arriviste.

Ellen Gilchrist's 1979 collection, *In the Land of Dreamy Dreams,* put her on the map with an unvarnished look at suicide, promiscuity, racism, and general craziness among elite New Orleanians. Her subsequent collection *Victory over Japan* received an American Book Award, and her later works secured a large following. She now lives in Arkansas.

The Pulitzer Prize–winning novelist Shirley Ann Grau, along with Patty Friedmann, and others, have dissected patrician life from various angles, though none so trenchantly as Gilchrist. Even notable novels that are not about aristocracy per se have a marked tendency to make socially prominent people into villains. Using a murder as plot fuel, Frederick Barton's *With Extreme Prejudice* draws the circle of guilt around an aristocratic judge. Barton's deeper story, set in the 1980s, is of the city in racial conflict.

Christine Wiltz explores similar tensions in *Glass House,* the story of a young woman who returns to the city after many years away, when she inherits an old mansion. In these novels, Barton and Wiltz treat the cheek-to-jowl relationship of race and class as a terrain of common memory. Writes Wiltz: "Her dream had cleared some of her confusion and left a small crystal of understanding about what she was trying to come to terms with: not only the lives of blacks and whites, but the fates of both races were connected by their dependence on each other. No matter

how much each race would try, there could be no separation. What one did affected the other; neither could thrive unless both did."

Saint Walker

Walker Percy (1917–1990) grew up a patrician in the Mississippi Delta and settled in Covington, Louisiana. Percy focused on the loss of spiritual values caused by faith in technology. He won the 1961 National Book Award for *The Moviegoer,* about Binx Bolling, a wellborn New Orleanian detached from a world subsumed by "the great shithouse of scientific humanism where needs are satisfied, everyone becomes an anyone, a warm and creative person . . . and ninety-eight percent believe in God and men are dead, dead, dead."

Each of Percy's six novels follows an existential quest, through knight-errant protagonists, for spiritual meaning in a New South of rich suburbs and soulless shopping malls. Percy was a brilliant satirist; yet his treatment of privileged society is just as striking for its kindness, an acceptance of sin-as-frailty.

"In New Orleans," he wrote in *Lancelot,* "people are happiest when they are going to funerals, making money, taking care of the dead, or putting on masks at Mardi Gras so nobody knows who they are."

If Walker Percy has a spiritual heir among younger southern writers it would have to be John Gregory Brown, who received the Lyndhurst Prize for *Decorations in a Ruined Cemetery,* and now teaches at Sweet Briar. The novel follows a young woman's search through buried racial secrets of a family with a forebear who cast statues for use as icons in cemeteries. The prose has a quality of incantation, reflecting the author's Catholic upbringing in New Orleans, where *Decorations* is set:

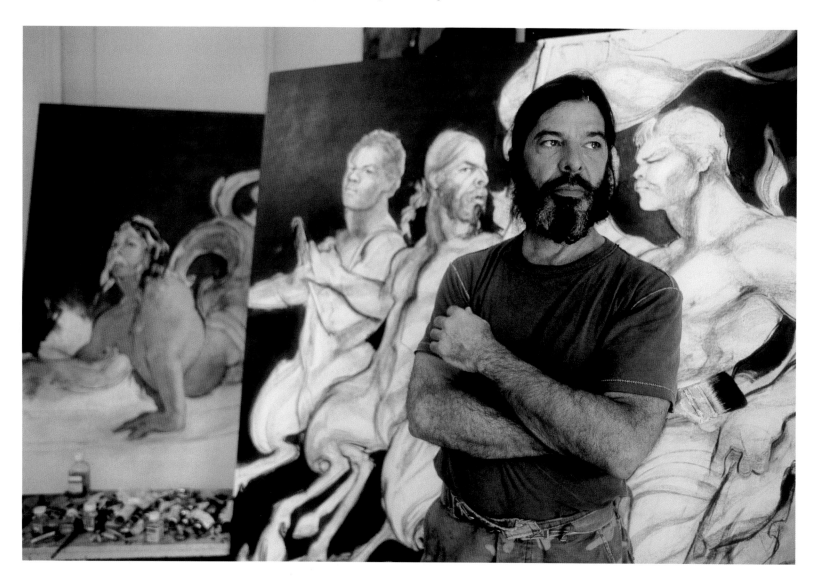

1983 A mermaid emerges from the sea and satyrs lurk behind New Orleans artist George Dureau in his studio.

How is it, I wonder, that suffering does all it can to make poets of every one of us, stirring up a kind of speech we never thought we'd utter, like we're all Shakespeare's King Lear standing in the middle of the storm, or for that matter, a man like your grandfather weeping in a statue garden. That may not be how my words read, but it's certainly how I feel, like the sky is falling all around me and all I can do is send out to you this faint message, which in the end is no louder than the beating of my heart.

Linkages

John Gregory Brown's metaphor of cemetery-as-family echoes a visual sensibility forged by the photographer Clarence John Laughlin in the 1940s. Laughlin was best known for *Ghosts along the Mississippi*, a highly impressionistic account of Louisiana plantation houses, some of them in ruins. In his urban images as well, Laughlin found inspiration in wrecked houses, gardens, and menacing trees; he created phantasmagorical scenes, a surreal treatment of the city and rural environs. The aging mansions—like his famous cemetery photographs, which have influenced countless southern artists—capture what Laughlin called "the beauty that comes out of time, that transcends decay."

Laughlin's self-styled "extreme romanticism" created a visual iconography specific to New Orleans. The photographer Josephine Sacabo, who captured a gray, dreamlike aura of New Orleans in the 1970s, widened her lens on foreign cultures in the eighties and nineties, with acclaimed exhibitions in Madrid and Mexico City. The shadowy photographs of Sandra Russell Clark in *Elysium: A Gathering of Souls* extend the sense of beauty transcending decay with trees that seem in motion behind stark mausoleums, lonely stone angels looking down from the sky, and spidery lines splayed on white-pebble walkways by sinuous tree limbs.

The drenching Catholicism of New Orleans cemeteries has achieved a mythical presence in countless works of visual art.

Valerie Martin absorbed these influences from childhood through college; she now lives in upstate New York. A Gothic darkness colors her short stories and the novel *Mary Reilly.* Martin's fiction is steeped in spirituality; however, she transforms it into a climate of impassioned naturalism. Perhaps her best book, *A Recent Martyr,* is set in a New Orleans quarantined because of a plague. Two women and a man are snared in sexual and spiritual cross- yearnings. One passage, in perfect pitch, captures the sensibility of most Louisiana artists:

It's an odd sensation to recognize in oneself the need to be in a particular physical environment, when one longs for the home ground no matter how terrible the memories it holds, no matter how great the efforts made to leave it behind. So I have left this city again and again and thought myself lucky to escape its allure, for it's the attraction of decay, of vicious, florid natural cycles that roll over the senses with their lushness. Where else could I find these hateful, humid, murderously hot afternoons, when I know that the past was a series of great mistakes, the greatest being the inability to live anywhere but in this swamp? I can't do without the little surges of joy at the sight of a chameleon, of a line of dark clouds moving in beneath the burning blue of the sky. I am comforted by the threatening encumbrance of moss on trees, the thick, sticky, plantain trees that can grow from their chopped roots twenty feet in three months, the green scum that spreads over the lagoons and bayous, the colorful conversations of the lazy, suspicious, pleasure-loving populace. I don't think I will leave the city again.

Laughlin's "extreme romanticism" and Martin's "pleasure-loving populace" are central to the works of George Dureau, one of New Orleans's leading artists. Dureau's paintings evoke the Dionysian spirit of Carnival and café society with large canvases marked by an overpowering *lushness,* rich tones of earth and sky, and a charged eroticism in the classically stylized nudes, mythological figures and high-living folk, decked out in fineries. Dureau's feast of the senses is a far cry from blueblood-bashing.

For more than thirty years, Dureau has rarely left the city. Ironically, his international reputation has come not from the paintings, but from his black-and-white photographs of dwarves, men without legs, or otherwise missing limbs, people whose bodies make them marginal in a media culture that prizes sex and glamour. Dureau, who befriends his misshapen models, endows them with an austere beauty. The art critic Douglas MacCash compares these images by Dureau to the famous photographs of prostitutes in the Storyville bordello district taken by E. J. Bellocq in the early 1900s. "The absence of many props or décor psychically links the model and the photographer in a way that might be lost if the model seemed more at home," wrote MacCash in a *Times-Picayune* review. "In both men's photos, there seems to be no one else in the universe, only the artist and his subject. Each would be terribly lonely without the other."

Photographer Herman Leonard moved to New Orleans after a long residency in Europe. His book *Jazz Memories* is a gathering of exceptional photographs of artists he followed in New York and Paris. In the 1990s Leonard turned his considerable talent to

an extraordinary series of images on New Orleans jazz and the musical culture.

Two other color photographers produced popular books in the nineties.

Richard Sexton's images in *New Orleans: Elegance and Decadence* (with text by Randolph Delehanty) cover shotgun houses, Caribbean cottages, and an impressive cross-section of interiors with adroit use of color. Sexton finds shimmering, liquid qualities in natural light, the hues of walls and cypress or pine floors.

Kerri McCaffety's *Obituary Cocktail* treats the bars and lounges, high and low, of the Crescent City with a balance of elegance and visual wit.

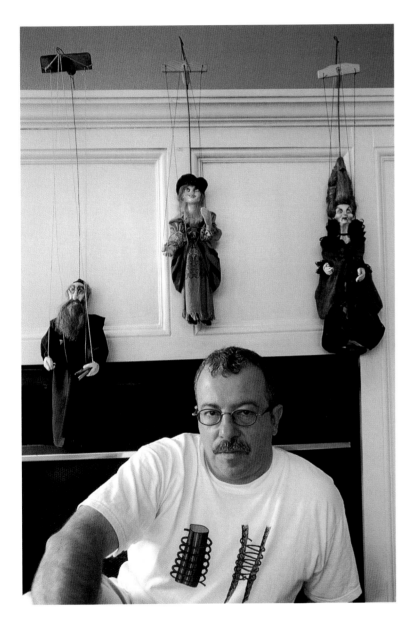

1999 Poet Andrei Codrescu sits with three marionettes representing characters from his native Romania: a rabbi, a wench, and a witch.

Watch out for plastic-coated marching girls

The Old World ambience of the French Quarter has long been a magnet to writers and artists. In the 1920s, Faulkner and Sherwood Anderson lived cheaply in Quarter digs; the young Faulkner wrote of the Vieux Carre's "faintly tarnished languour like an aging yet still beautiful courtesan in a smokefilled room, avid yet weary too of ardent ways." He went back to Mississippi, where the flow of his famous novels began. As the years passed, Tennessee Williams, Truman Capote, Lyle Saxon, and Robert Tallant lived in the Quarter amidst people who hungered along the edge, some seeking safe harbor, others romantic bohemians, still others blinkered lost souls like Blanche DuBois in *A Streetcar Named Desire,* relying on "the kindness of strangers."

Andrei Codrescu, who divides his time between the French Quarter and Baton Rouge, where he teaches at LSU, is a celebrant of bohemia. Codrescu wears many capes as a litterateur, generating a flow of essays, poetry, novels, books on travel and politics, and commentaries for NPR's *All Things Considered.* At heart he is a critic, using language like a sword, slashing away at the stupidity of politics or horrors of history, only to sheathe the blade and turn on the charm. Perhaps it takes a Romanian exile, with rapier wit softened by an émigré's sense of American wonder, to find new inspiration in an old show, as Codrescu has done in his recurrent takes on Mardi Gras. From *Zombification:*

> First came the plastic-coated marching girls with light shining through them, looking like water fairies. They were followed by the St. Augustine Band with rivulets flowing off their drums and dripping glistening brass, weird water gods in Roman helmets driving forth the wet plastic fairies. Soaked floats with shiny, oversized heads, grotesque eyes, and fat puckered lips, glided forward full of masked goblinesque critters throwing gold and silver doubloons and beaded jewels through the already jeweled strands of rain. . . . That's the one thing every year that I notice about Mardi Gras, whether I pay any attention to it or not. Everything looks as if it should be or already was painted, photographed, filmed, reproduced. And for all that, it's still real, three-dimensional and unfailingly bizarre.

Paradise lost, in words and paintings

James Lee Burke's novels featuring the detective Dave Robicheaux have earned him a national following and literary status rare for crime writers. The Robicheaux novels nearly transcend the genre. A deputy sheriff—and recovering alcoholic, Vietnam vet with post-traumatic flashbacks, plus ex-New Orleans cop to

1999 Writer James Lee Burke at home in New Iberia.

boot—Dave lives on a bayou outside New Iberia. These novels begin with tentacles of evil reaching down to the pier outside Robicheaux's Edenesque hideaway, drawing him into a fallen world. Burke's novels of the 1980s and 1990s are in some sense a mirror on the political and social conflicts of a time when chemical polluters, drug gangs, and David Duke made headlines. Burke creates a dynamic tension between beauties of a natural world and those who violate anything for money. His descriptions of the marshes, wetlands, and semitropical vistas could be transposed as text to the exhibition catalogs of painters like Jacqueline Bishop and Emery Clark of New Orleans, whose works explore an ecology of colors evocative of these latitudes, or of Elemore Morgan Jr., the renowned landscape artist of Cajun country. From *Heaven's Prisoners:*

1999 Allison Stewart stands before one of her impressionistic swamp paintings outside her studio, a converted old neighborhood store in uptown New Orleans.

> I was just off Southwest Pass, between Pecan Island and Marsh islands, with the green, whitecapping water of the Gulf Stream to the south and the long, flat expanse of the Louisiana coastline behind me—which is really not a coastline at all but instead a huge wetlands area of sawgrass, dead cypress strung with wisps of moss, and a maze of canals and bayous that are choked with Japanese water lilies whose purple flowers audibly pop in the morning and whose root systems can wind around your propeller like cable wire.

The perils that surround detective Robicheaux have a metaphorical interpretation in the works of Allison Stewart, who mounted a 1999 exhibition entitled *They Called It Paradise* at the Arthur Roger Gallery in New Orleans. Stewart considers her paintings "visual diaries, notes to myself about vanishing landscapes and vanishing cultures. . . . I am particularly interested in the intersection of the natural world with the manmade environment and in recent years I have observed the profound changes that man has brought to the natural terrain."

As erosion of the wetlands made news in the 1990s, Louisiana had 40,000 waste dumps from oil field drilling, according to data released by the state.

More writers

Rodger Kamenetz, author of *The Jew in the Lotus,* among other works on Jewish mysticism, is a poet who teaches at LSU, where his wife, Moira Crone, novelist and author of the short-story collection *Dream State,* directs the creative writing program.

The novelists David Madden and James Gordon Bennett also teach in the LSU English department. The poet Peter Cooley is a professor at Tulane; his daughter, Nicole Cooley, is a poet and novelist. John Biguenet, a professor at Loyola of New Orleans, has published short stories in *Granta* and *Esquire.* His first book of fiction, *The Torturer's Apprentice,* was forthcoming at the time of this writing. Fiction writer and music essayist Tom Piazza made New Orleans his base after years in New York and Iowa.

Robert Harling's play *Steel Magnolias* made his hometown of Natchitoches famous in the film version. James Wilcox, author of *Modern Baptists* and other novels, draws on his hometown of Hammond as a setting. John Ed Bradly, a novelist and *Sports Illustrated* writer, grew up in Opelousas and lives in New Orleans.

Two historians

John Barry, another former journalist, is the author of *Rising Tide,* an award-winning history of the Mississippi River flood of 1927 and the devastation wrought on the Mississippi Delta and areas below New Orleans. Barry, who divides his time between New Orleans and Washington, invests his protagonist, the river, with metaphysical powers reminiscent of Old Testament plagues sent to punish mankind: "There is no sight like the rising Mississippi. One cannot look at it without awe, or watch it rise and

press against the levees without fear. . . . Unlike a human enemy, the river has no weakness, makes no mistakes, is perfect."

Against nature's perfection, Barry casts a succession of powerful men as supporting players, swept along by efforts to control currents more powerful than themselves. Barry approaches these politicians, planters, bankers, and lawyers of the 1920s with the moral fuel of a muckraker, an insistence that truth must speak to power. The decision to dynamite levees south of New Orleans, supposedly to spare the city, created horrendous flood damage in areas of St. Bernard Parish, devastating the lives of many people who were poor to begin with—damage that could have been avoided. The plan was pushed through by a patrician attorney in a meeting with business leaders that did not even include the city's mayor. Barry's indictment of elite society in New Orleans and Mississippi's Delta counties echoes the condemnations of novelists we have mentioned, though his issue is specific and abundantly documented.

Gwendolyn Midlo Hall may have produced the most important historical work about Louisiana in the last generation. A professor of history at Rutgers for many years, she had family ties to New Orleans. In 1992 she published *Africans in Colonial Louisiana: The Development of Afro-Creole Culture in the Eighteenth Century,* which received several prestigious awards, including a Bancroft. Drawing on years of research in far-flung French colonial archives, Hall wrote of how the early-eighteenth-

century Bambara slaves, from an area now encompassed by Mali, transplanted a memory and set of values in Louisiana. As slaves from other regions arrived, a culture arose of great adaptive capacity. Hall writes of colonial life as the slaves experienced it, and of how Africans forged traditions to carry them beyond mere survival. She writes of slave revolts and an oral tradition, shaped by an African sensibility, that kept alive the ties to a mother culture, as well as to the memory of rebellious leaders who fought and died for freedom.

"The chaotic conditions prevailing in the colony, the knowledge and skills of the African population, the size and importance of the Indian population throughout the eighteenth century, and the geography of lower Louisiana, which allowed for easy mobility along its waterways as well as escape and survival in the nearby, pervasive swamps, all contributed to an unusually cohesive and heavily Africanized culture in lower Louisiana; clearly, the most Africanized slave culture in the United States."

Hall has since retired from Rutgers and lives part of the year in New Orleans. With support from the NEH, the Guggenheim Foundation, and research assistants, she has amassed a database of 100,000 Africans who were enslaved in Louisiana from 1719 through 1820. In Louisiana, more information has been amassed about individual enslaved Africans than in "any other place in the Western Hemisphere," states Hall. The breadth of her work will register for many years, not only among historians, but with people of color searching for information about their past.

Brenda Marie Osbey . . . excavations of Africans and Creoles

Louisiana has a substantial community of African American writers.

Terrance Hayes, a twenty-seven-year-old poet who teaches English at Xavier University, received a prestigious Whiting Writers Award after the publication of his collection *Muscular Music.*

Louis Edwards, author of the novels *Ten Seconds* and *N: A Romantic Mystery,* has received a Whiting Award and a Guggenheim Fellowship.

Pinkie Gordon Lane, who teaches at Southern University in Baton Rouge, has served as the state's poet laureate. Kalamu ya Salaam of New Orleans is a prolific poet, social critic and music writer.

1999 Poet Brenda Marie Osbey meditates beside a small altar at her residence in the Tremé district of New Orleans.

Brenda Marie Osbey, a poet and essayist, received the American Book Award for her 1998 collection of poems, *All Saints*. Osbey lives in a nineteenth-century cottage in Tremé, just outside the French Quarter. *All Saints* reflects her research into the history of Tremé, which was built by free persons of color, many of whom had come from Haiti. Osbey's poetry excavates a chronicle of Tremé's history, summoning voices of folk healers, musicians, and forgotten figures like Luís Congo, a free African who performed executions of slaves in the seventeenth century. Osbey's Tremé is a geography of memory and spiritual links. From "Faubourg":

> the faubourg is a city within the larger city
> and the women walk in pairs and clusters
> moving along the slave-bricked streets
> wearing print dresses
> carrying parcels
> on their hips or heads . . .

> the dead must be mourned and sung over
> and prayers told them to carry to the other side.
> the dead must be chanted and marched to their tombs
> and the tombs then tended and the dogs kept away.

Lines from another poem, "Peculiar Fascination with the Dead," advocate responsibility to the ancestors, the living-dead who circulate amongst us:

> light candles to honor the dead.
> set flowers on the altars of the dead
> which must be raised in your home.
> wear the memory of the dead plainly
> so anyone looking will see
> how the decent do not forget.
> speak of the dead
> as though you thought they might hear
> from the adjoining room.

"Death is never just death for us; it symbolizes something," Osbey explained in an interview with the literary scholar John Lowe, published in *The Future of Southern Letters*. "Even when people are dead, we maintain relations with them. We don't want anything to end, and so the dead are always there for us. . . . We have jazz funerals and a city that is constantly surrounded by death: the cemeteries, above ground, decaying buildings; everything is a little bit worn in New Orleans and somewhat irreplaceable. And that's how people in our lives function—irreplaceable. We cannot release them to the grave; we maintain that

1993 Robert Olen Butler, a Pulitzer Prize–winning author who lived in Lake Charles for many years, has written extensively on Vietnam and Vietnamese living in New Orleans.

connection beyond the grave. If anything, we intensify those connections beyond the grave."

Osbey's *dramatis personae* are more spiritual than the cultural figures of Leslie Staub's pantheon of saints and sinners. "Mother Catherine" is a poem about a church leader and folk healer of the 1920s, an illiterate woman who sheltered battered women in a tent compound on land she purchased deep in the lower Ninth Ward, downriver from the city proper. The poem covers three and a half pages in *All Saints,* and is an act of revisionist history as well. Mother Catherine was a leader of the Spiritual move-

ment that spread through the city in the 1920s. The ministers, mostly female, summoned spirits in acts of Christian veneration. Brass band musicians played at services that achieved ecstasies in which believers fell into trancelike possessions, "caught in the spirit." *Gumbo Ya-Ya,* a best-selling compendium of folklore drawn from interviews conducted by the Federal Writers Project during the depression, puts Catherine Seals in a derogatory light; yet many people, including Italians, credited her with miraculous healing of sick people brought to her services.

What is Komunyakaa saying?

When he received the 1994 Pulitzer Prize for Poetry, Yusef Komunyakaa was teaching English at Indiana University, several years removed from a long stretch on the UNO faculty. He is now at Princeton. Born in 1947 in the town of Bogalusa, sixty miles northeast of New Orleans, Komunyakaa (a name he adopted as an adult) was active in the New Orleans Poetry Forum for many years. Like Osbey, Komunyakaa is a poet whose primary theme is memory.

Komunyakaa's poems surround the past—childhood recollections at one turn, tapping a well of blues and jazz at another, exploring the beauty and violence he encountered in Vietnam yet again. The sum of these parts, the whole of his work, rings a brooding yet tender voice: the writer of lyrical lines folds into a realist who demands an unflinching stare at raw truth.

A longing for obedience to nature's better impulses roams through his poems. "I grew up with guns around me," he told the *New York Times.* "The rituals of violence. People hunting. Killing hogs, rabbits. . . . At the time it seemed pragmatic, but now I question it." Bogalusa is a touchstone of his work; few towns contain such outsized dimensions of southern darkness. A paper mill town, shadowed by pungent factory clouds, it was a civil rights battleground in the 1960s where a group of black activists, unwilling to passively endure a violent Ku Klux Klan, banded together, with arms, as the Deacons of Defense. A generation later Klan sympathizers gave a rousing welcome to politician and white supremacist David Duke.

"Fog Galleon," from Komunyakaa's 1993 collection, *Neon Vernacular: New and Selected Poems,* sounds a lamentation of returning home:

> I press against the taxicab
> Window. I'm back here, interfaced
> With a dead phosphorescence,

> The whole town smells
> Like the world's oldest anger

As a young army man Komunyakaa went to Vietnam as a reporter for a military newspaper and earned a Bronze Star. "I've been through a healing process in two places," he said in another interview, referring to Bogalusa and Vietnam. "I think both experiences have been linked together for me in a lot of ways."

The boldest of Komunyakaa's poems in the mid-nineties took a radical departure from the structural foundations of verse by using parallel columns. On the right, a collective consciousness rubs against characters whose voices carry down the left side of the page. From "Changes, or Reveries at a Window Overlooking a Country Road, with Two Women Talking Blues in the Kitchen":

Joe, Gus, Sham . . .	Heat lightning jumpstarts the slow
Even George Edward	afternoon & a syncopated rainfall
Done gone. Done	peppers the tinroof like Philly Joe
Gone to Jesus, Honey	Jones' brushes reaching for a dusky
Doncha mean the devil,	backbeat across the high hat. Rhythm
Mary? Those Johnson boys	like cells multiplying . . . language &
Were only sweet talkers	notes made flesh. Accents & stresses
& long, tall bootleggers	almost sexual. Pleasure's knot, to wrestle

Juxtaposing dialogue and description, Komunyakaa achieves a fusion of rhythms—music rhythms, speech rhythms; they undergird both sides of his poem of psyches. The "syncopated rainfall" that suggests the percussive strokes of drummer Philly Joe Jones is straight out of jazz. For a poet so steeped in music and oracular influences, the verse tale of women seated at a window poses a challenge: Can one person read it aloud?

Probably not. Yet the lines are well drawn, the distance clear between the women-in-dialogue and a landscape of memory and culture. Komunyakaa's poetry is haunting, often surreal, yet always insistent on the idea of memory as salvation more than curse. On a trip back to the city in the fall of 1994, where he joined old friends from the New Orleans Poetry Forum for a reading at the home of Lee Meitzen Grue, Komunyakaa was signing copies of *Neon Vernacular* in the hostess's living room when a young woman asked him about inspiration.

"I guess the things of my past," he said courteously. He was tired. She hung on his words, waiting it seemed for some inspiration herself.

"And music, yes, the music," he murmured.

Visions of John Scott

John Scott is one of the South's preeminent artists. A longtime art professor at his alma mater, Xavier University, Scott has received a MacArthur Fellowship, among other awards, and his works have been widely exhibited. His outdoor sculptures and smaller pieces for galleries have a dazzling rhythmic quality, a fusion of color and form that shimmer with suggestions of poetic movement. "What I've been trying to do for the last thirty-something years is make a piece of art that would be similar to what African American musicians have done with gospel and blues and jazz. So that when you hear it, it wraps around your soul," Scott explained in a 1994 interview with LEH president Michael Sartisky for *Louisiana Cultural Vistas.*

Poydras Street Dance, Uptown Second Line is an installation that hangs from the lobby of a large office building at 1515 Poydras, in the heart of New Orleans's downtown commercial district. A series of bright, multicolored rods suspended from the ceiling conveys a sense of linear motion, while the vertical bars conjure human shapes, coursing forward like second-liners in a parade.

Scott later expressed satisfaction that the large corporate space had been transformed by the installation: "Now people congregate there. . . . So, it says something about how the spirit of that place has been changed."

There is a great range in the size and settings of Scott's pieces, which have imbued many spaces with the artist's intense spiritual designs. He grew up in the lower Ninth Ward (the neighborhood where Fats Domino still lives) in a family of people who took pride in knowing how to use their hands to make, paint, repair, retool, or otherwise shape the things of life to conform to their needs. At Booker T. Washington High School he found a lifelong mentor in art teacher Albert Jean. As an undergraduate at Xavier, Scott studied sculpture with Numa Rousseve and a nun, Sister Lurana, among others in a department that was remarkable for both the quality of teaching and the camaraderie in which students and professors helped one another.

As a young sculptor Scott executed religious pieces for Catholic churches and did public murals; he also made an intense study of European masters, the sculptural works of Henry Moore, and African tribal carvings, which were objects used for ritual purposes.

The religious sensibility in Scott's works is striking. Much of his *oeuvre* reflects the balance between ritual and tradition. By the 1980s, he explained in *Cultural Vistas,* "one of the things that

dawned on me is that the people I needed as role models were not visual artists at all. As an African-American trying to work out of the spirit of that, I realized that it was the jazz musician that had become the teacher for me. When we came here, there were certain things that we were allowed to do and there were things that were not allowed. The visual tradition that we had for thousands of years was interrupted. The musical tradition was more or less allowed to continue. . . . Visual artists, on the other hand, became almost totally utilitarian. They had to do the brick work, the iron work, the carpentry, etc. When I began studying art, all of my role models, primarily, were in the Western idiom. But the people who were creating a new language were the musicians."

Scott found a spherical quality in the music. He wanted his own pieces to achieve something like the simultaneous movement of jazz polyrhythms. He had many conversations with jazz pianist Ellis Marsalis that helped Scott clarify the direction his output would take. While working on an installation for the African Pavilion of the 1984 Louisiana World Exposition, he read about the myth of a hunter who felt sorrow after killing his game and played the string of his bow as "a libation of sound to the soul of the animal that gave its flesh to feed the people," he recalled. The research trail led Scott to accounts of slaves in the Mississippi Delta who, in a prefiguring of the blues, would stretch wire from a porch post to a gourd or can and make notes on the wire with their fingers. It was called the Diddley-bow. Later, Scott did an exhibition series called *Diddley-bow,* using prongs to resemble human shapes, connected by wires, resulting in figurative instruments. One piece, *Duet for Booker and Fess,* commemorates James Booker and Professor Longhair.

Scott has created homages to young murder victims, pieces that mock Hollywood's glorification of criminals, and a range of outdoor sculpture works in various cities. There is a moral ethos in his work, and a generous vision of humankind that, while rooted in the black experience, reaches a higher plane of universal expression. If art is a search, in the truest sense, the odyssey of John Scott is one of the great epics of Louisiana history.

Cajuns and Creoles

In 1968, CODOFIL—the Council for the Development of French in Louisiana—began to reinvigorate the teaching of the mother tongue in schools of the outlying southern parishes where it had been banished for years. This is the region where eighteenth-century immigrants, driven by the British out of Acadie, in Nova Scotia, fashioned a new life. They came to

1994 New Orleans artist John Scott peers through his piece *Doorway to the Blues.*

Louisiana's interior, far removed from the port of New Orleans, on the prairies girded by bayous on either side of the huge Atchafalaya Basin that drains into the Gulf of Mexico. Over time, with cadences of the patois, the Acadians came to be known as Cajuns. Today the region is called Acadiana.

In a landmark 1984 study, *Makers of Cajun Music* (recently reissued, with updated text, as *Cajun and Creole Music Makers*), the writer and folklore scholar Barry Jean Ancelet gave context to the blossoming of a long-suppressed regional identity: "Throughout the Western world, it has been difficult to avoid the homogenizing influence of American culture, yet America has failed to reduce its own diverse ethnic and cultural heritages to pabulum, largely because of the resiliency of individual cultures."

Cajun dance bands, built around the accordion and the fiddle, kept alive French-language songs for years after the language was banned by schools in the region; educators had viewed the patois pejoratively, rather than as a sign of cultural survival. By the late 1970s, French-lyric songs were galvanizing a baby-boom generation of dancers in and around the hub city of Lafayette. Michael Doucet and his band BeauSoleil, as well as older Cajun musicians like the Balfa Brothers, began traveling to points afar, carrying an idiom to domestic and foreign audiences hungry for roots music resistant to the "homogenizing influence" of mass culture. Dewey Balfa and his brothers have passed away; but Dewey's daughter Christine leads a band, Balfa Toujours, which has a following on the national circuit of concerts and festivals.

"Much of our American popular culture in music is based on traditional sounds from the South, south Louisiana and New Orleans," notes Nicholas Spitzer, who founded the state's Folklife Program in the 1970s, moved to Washington to work as a folklorist at the Smithsonian, and has returned to Louisiana, hosting the nationally syndicated public radio program *American Routes* from New Orleans.

"Much of what is now viewed as 'traditional' local culture was either a radical culture development (the origins of jazz) or an influence of popular cultures (the addition of the internationally popular accordion to Cajun music in the late 19th century)," writes Spitzer in *Cultural Vistas*. "As the place where jazz was born, rhythm-and-blues and rock-and-roll evolved, and new countrified versions of Cajun music or zydeco funk thrive, Louisiana is a remarkable and influential example of how the mixing of culture has worked over three centuries. Both the routes into our society from other places and the musical roads out of our state have been important and well-traveled byways."

Alongside the music, a group of poets—Barry Jean Ancelet

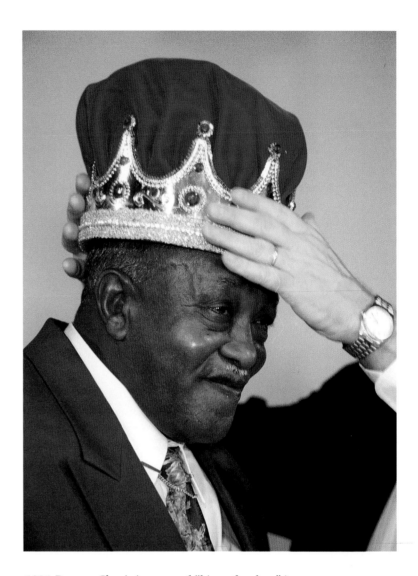

1994 Boozoo Chavis is crowned "king of zydeco" in a ceremony at Acadian Village in Lafayette. Holding the crown is A. J. LeBlanc, Acadian Village's director. After thanking the audience and all his other fans, Chavis proclaimed with characteristic aplomb that in truth he had always been king of zydeco.

(writing his poems as Jean Arceneaux), Debbie Clifton, and Zachary Richard among them—in the Lafayette area in the 1970s were writing and giving readings at home and in French-speaking provinces of Canada.

The 1970s' musical explosion surrounding Lafayette was by no means the work of Cajuns alone. The black singer and accordionist Clifton Chenier became a folk hero as the "king of zydeco."

Clifton the king

In the late 1940s Chenier quit working in the oil fields and took his band into working class communities in Texas and California

where black Creoles had migrated. Chenier's stylistic attack on the accordion built on triplets that snapped like drumbeats and tremolos that quavered with long hot gushes of the blues; his voice was an instrument in its own right. Chenier and his Red Hot Louisiana Band sometimes played four hours at a stretch with blazing force; Clifton's passionate night-soaring vocals triggered chain reactions in a thousand clubs and roadhouses where floors would shake like tin roofs in throbbing rain and people danced like there was no tomorrow.

Clifton Chenier was the force behind zydeco as it broke out of regional boundaries into the popular culture. He took songs by Ray Charles and other R&B artists and refashioned them with

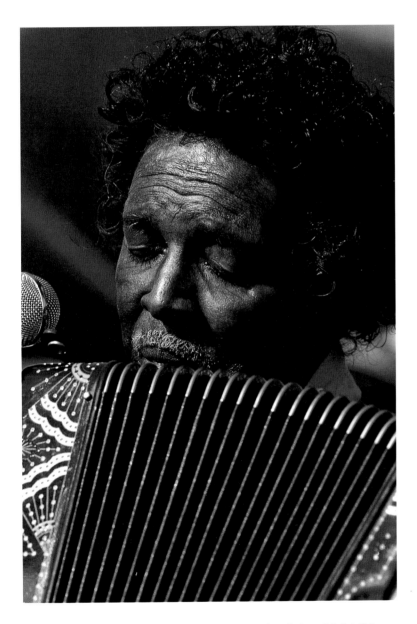

1987 Clifton Chenier, the original "king of zydeco," sings his hit "I'm Coming Home" at the Plaisance Zydeco Festival. It proved to be his last Louisiana performance. He died later that year.

French lyrics and that driving zydeco beat. Clifton could be ornery, too. Legend has it that when Mick Jagger sent word that he would like to sit in on a nightclub set, Chenier, who had only the vaguest knowledge of the existence of the Rolling Stones, snorted: "*Nick? That punk!*" He didn't have much use for academics or reporters and generally avoided interviews. He did give a long and important one to author Ben Sandmel in which he reflected on his heritage: "All my people speak French, and I learned it from them. A lot of people, they was kind of 'shamed of French, but one thing they didn't know was how important French is to 'em. You understand? You be around here, you meet a lot of people, they don't even know how to talk French, right here in Louisiana, but now, if they're in a city like Paris, they need it. There's a lot of people holding back on French, you know, but me, I *never* was ashamed of French."

When Chenier died in late 1987, the sense of loss among zydeco followers was large. The intensity of sentiments surged a few weeks later when Mayor Dud Lastrapes of Lafayette unwittingly agreed to crown Rockin' Dopsie the new king of zydeco in a ceremony at a local hotel. A howl of protests rose, embarrassing the mayor. For zydeco aficionados, the king might be dead, *but Clifton was still king!* Those attitudes have softened somewhat in the last dozen years as a new field of zydeco royalty has emerged.

Zydeco experts weigh in

The flood tide of zydeco musicians has continued with the roaring comeback of Boozoo Chavis (the recently crowned king); the grand tours of Buckwheat Zydeco (Stanley Dural), the idiom's great popularizer in the nineties, with appearances on late-night talk shows and as an opening act in arena-rock tours; the rise of younger stars like Chris Ardoin, Geno Delafose, and the continuing journey of Clifton's son C. J. Chenier and the Red Hot Louisiana Band.

"Zydeco is the traditional dance music—and the dance—of the black Creoles of Southwest Louisiana," writes Michael Tisserand in *The Kingdom of Zydeco.*

> Confusion usually starts with a confusing word: "Creole." Derived from the Latin *creare,* which means "to create," "Creole" has created new meanings for itself around the world. It has been applied to all colonial-born persons, and its meaning is entangled in the briars of class and race. For the Portuguese, a *crioulo* meant a slave of African descent born in the New World; this meaning was used in Louisiana as well. Paradoxically, it was also used to designate society members of

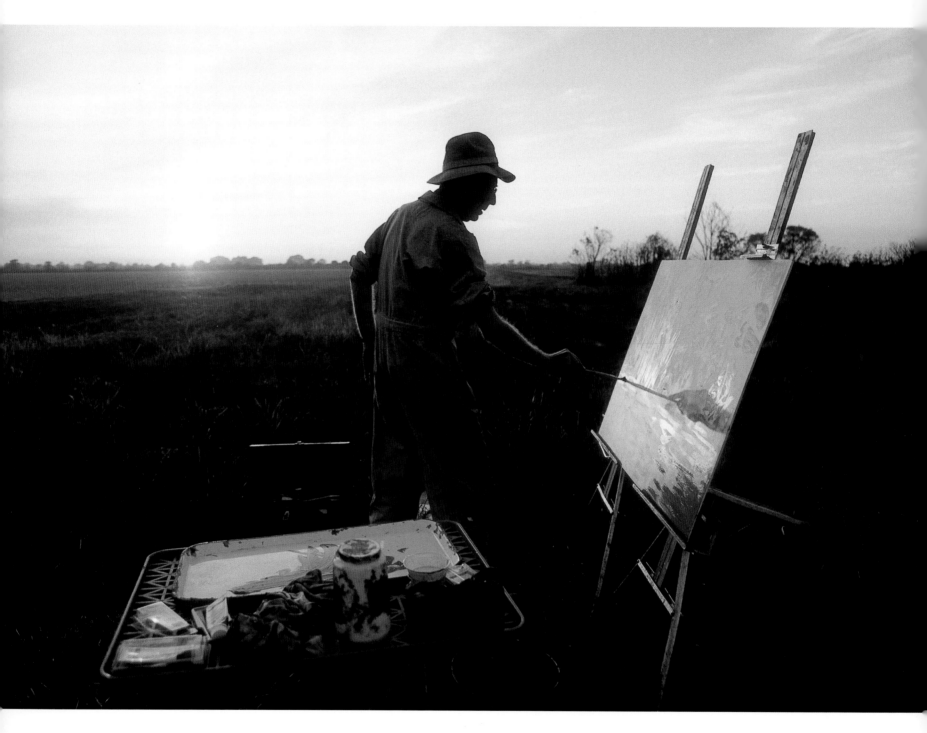

1989 Elemore Morgan Jr. paints a landscape on the south Louisiana prairie near his home in Leroy.

1990 Lafayette artist Francis Xavier Pavy employs Louisiana
iconography in many of his paintings.

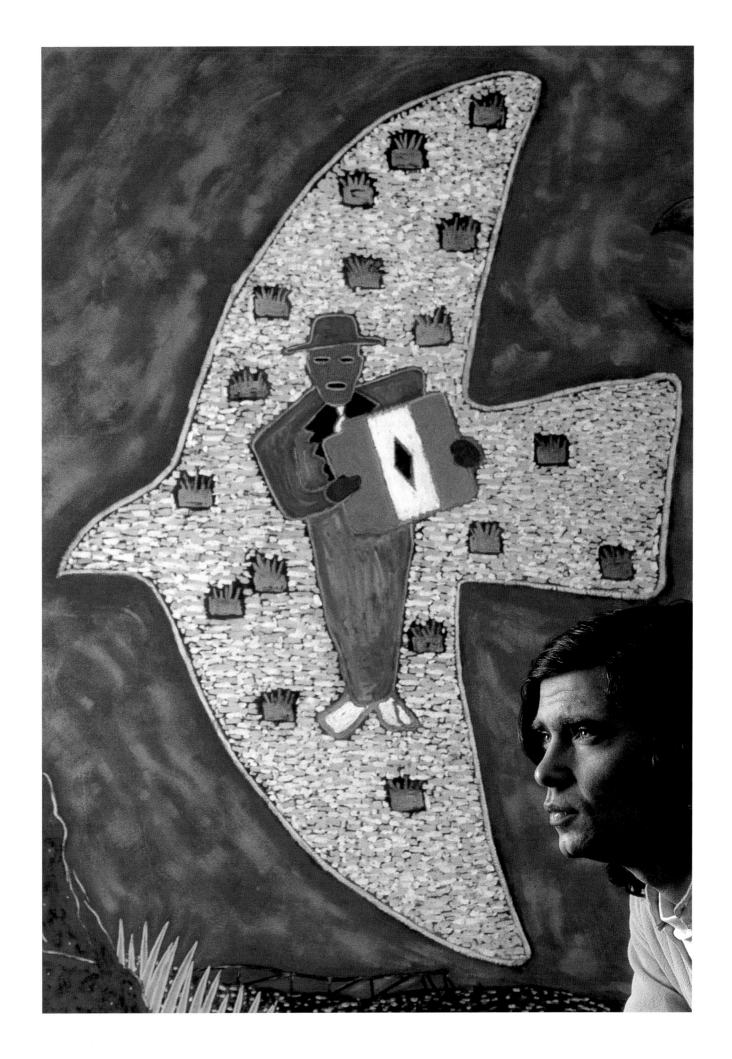

European descent. . . . But on the other side of the Atchafalaya Basin, in the rural parishes, it is enjoying a renaissance. Here it is used by many—though not all—blacks to describe their heritage and values. When people in Southwest Louisiana describe themselves as "black Creole," they usually mean that they prefer a way of life that expresses itself in traditional food, the French language, and zydeco.

The preoccupation with these labels is intense, as Ben Sandmel reports in *Zydeco!* Stanley Dural insists in his contracts that the word *Cajun* not be used for promotion and that zydeco not be advertised as New Orleans music. The percussive accordion play and swinging rhythm-and-blues signature that mark Dural's style are easily recognizable, and hard to imitate.

In a rural culture where black musicians and white musicians shared a bilingual sensibility, the racial barriers were real, though porous with subtle lines of reciprocity. "Cajuns learned style from black Creoles, and black Creoles learned repertoire from Cajuns," Barry Jean Ancelet has remarked. Zydeco was further delineated by guitars instead of fiddles, selective use of saxophones, and the *frottoir,* a corrugated rubboard worn over the chest, with fingers wielding bottle openers to scrape out rhythms of a percussive beat. Yet with the passage of time, neat delin-

eations are more difficult to make. Older Cajuns draw from the R&B songbags, and some Creoles are known to wail on the old modal scales of Cajun waltz and two-step vocals. Younger zydeco musicians veer toward a highly rhythmic accordion-cum-frottoir, rather than a more European melody played on accordion and fiddle.

Barry Jean Ancelet pinpoints a crucial factor in the Epilogue to *Cajun and Creole Music Makers:* "The simple truth is this: if the language fades, the music we now know as Cajun and zydeco will not survive intact. We will still eat gumbo, call ourselves Cajuns and Creoles, and refer to our music as Cajun and zydeco, but, without the French language, will the music have real cultural meaning?"

Image makers—Pavy and Morgan

As the visual artists of New Orleans have affinities with writers and musicians, so the southwest parishes' cultural mosaic has its parallels.

The painter Francis Pavy, who lives in Lafayette, uses bright bursting color fields overlaid with figurative images of trees, animals, musicians, and human beings. In *Birds Roosting,* a blue hat seems to be spinning on a yellow-and-black checkered backdrop, surrounded by a singer in a blue body suit with white spangled stars; a brown man with a white saxophone; a man colored dark purple, flecked with white stars, holding up a yellow trumpet; and finally, in the upper right hand corner, the red shadow of a man holding a yellow guitar. Pavy's surreal vistas, which at times seem to simulate the throbbing rhythms of zydeco music, have won him a legion of admirers. Pavy may be the only painter whose collectors included Mick Jagger and Walker Percy, not to mention singer-composer Paul Simon, film director Ron Howard; and the producer of *Saturday Night Live,* Lorne Michaels.

As Pavy moved on to metal cut images in the 1990s, his work still drew on strong primary colors as he explored images of dice, booze, musical instruments, urban buildings, phone poles and other tangibles. "Although by no means subtle, the vignettes depicted in these images fuse the

1994 Folklorist Barry Jean Ancelet confides with the audience about the Sundown Playboys, a Cajun group performing on the Rendez Vous des Cajuns radio show at the Liberty Theater in Eunice.

allure and mysteries of south Louisiana with the influence of legalized gambling, alcohol, mass communication and the encroaching of development on the landscape," wrote Jeff Rubin in a 1998 review of a Pavy exhibition in the *New Orleans Art Review.* "*Mortality and the Eternal Party* is a sort of morality play on the bayou, featuring Louisiana's passion for overindulgence and liquor bottles, with an empty pirogue floating like a funeral barge across the water."

A sense of visual rhythms, and color as a substitute for pulsing sound, is pronounced in works of many artists. Natural vistas of the region do not lend themselves to minimalist interpretations. It is not an environment of hard edges or tough colors. In the marshes, waters seem to recede into sky along a horizon with a shimmering, liquid quality.

The rice farming country outside of Lafayette has for many years been the visual domain of Elemore Morgan Jr., a retired art professor at the University of Louisiana at Lafayette (formerly the University of Southwestern Louisiana) who lives in rural Vermilion Parish. "Towns like Andrew, Meaux, and Leroy form the cultural centers of this private backyard, as I see it, consisting of vivid green rice fields in early summer, rioting clouds of the afternoon thunderstorms and the almost mystical quality of the meeting of the edge of the earth and the earth's atmosphere," wrote Morgan in a 1992 catalog for an exhibition, *From the Artist's Collection,* at Southeastern Louisiana University.

Morgan has painted hundreds of scenes of rice fields, most of them with acrylic on shaped Masonite panels. His work has been exhibited in New York, San Francisco, Los Angeles, Chicago, and Miami, among other cities.

"His paintings have the spectacular color and handling of Fauvist landscapes," wrote the art critic Terrington Calas in *Figaro,* a New Orleans weekly, in an early assessment of Morgan's

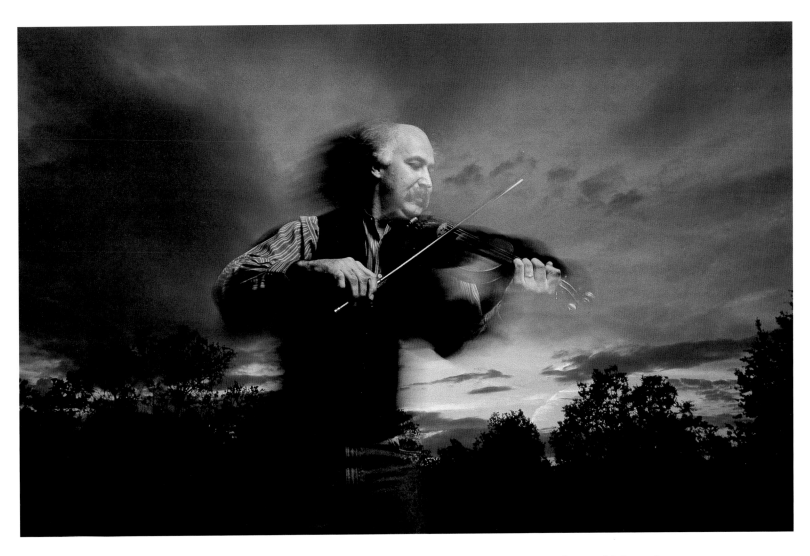

1989 Cajun Fiddler Michael Doucet of the group BeauSoleil plays against an evening sky near his home in Lafayette.

work. "He adroitly places intense cool colors over warm underlayers, generating brushwork that virtually leaps from the canvas."

"I seem to be fascinated by the edge of the planet as it meets the envelope of atmosphere around our planet," noted Morgan. "We talk about the horizon, the clouds, the sky, the sun going down, and all of these are part of the experience of seeing the earth revolving within its encompassing atmosphere."

At one time Morgan's father, Elemore Sr., worked as a sales representative and construction supervisor for the noted Louisiana architect A. Hays Town; he started photographing jobs in progress and eventually became a professional photographer. He had a marked influence on Elemore Jr., who earned a fine arts degree at LSU in the 1940s and then served in the military during the Korean War. Out of the service, Morgan studied at the Ruskin School of Art at Oxford University on the GI Bill. Back in Lafayette, he began working on commissioned murals and teaching at USL.

Like his father, Elemore Morgan Jr. is an accomplished photographer. His color photographs accompanied Ancelet's text in *Cajun and Creole Music Makers*. "We felt that these musicians exemplified some of the strongest elements in the Cajun character," wrote Morgan. "In particular, I was impressed that these men and women had become artists, in the truest sense, while supporting their families with ordinary occupations and with little outside recognition in the early days. In addition, we hoped that our documentation of these musicians would indirectly reflect the culture which produced this music and was being changed as it became more 'Americanized' by interstate highways, television and convenience stores."

Pavy and Morgan are a generation apart, with dramatically different stylistic signatures. Yet a certain commonality of influences links the two men who have created their own geographies of image from Acadiana.

As Allison Stewart, the New Orleans painter puts it, "The sense of color and celebration in the art here is not like an intellectual discourse. The colors reflect the culture and movement, like a kind of osmosis, passing back and forth between land and water and air."

Ancelet, Savoy, Doucet . . . et moi

As a teenager in New Orleans in the 1960s, I spent many hours listening and dancing to rhythm-and-blues musicians like the Nevilles, Irma Thomas, Allen Toussaint, and Fats Domino. Discoveries of jazz came later, in my twenties. The impact of Cajun

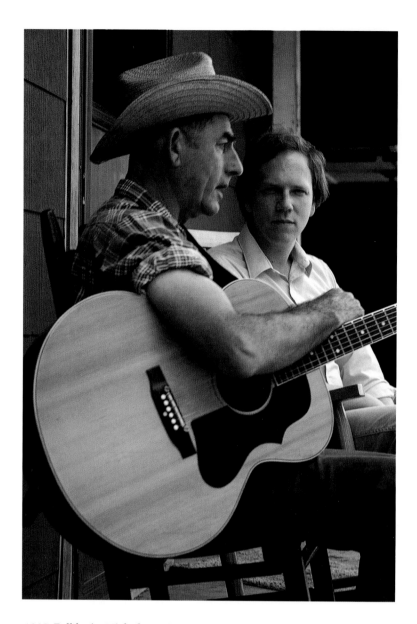

1985 Folklorist Nicholas Spitzer visits with D. L. Menard, Cajun singer and songwriter, at the musician's home in Erath.

music did not register on me until a glorious afternoon in Paris in the summer of 1982, as I watched the burly Michael Doucet play fiddle, with his brother David on guitar, in an ensemble before a rapt audience at the Pompidou Center. The band BeauSoleil was then in its infancy. By the ephemeral standards of pop culture, their success has been a wonder to behold. Imagine what it took for a six-piece Cajun group, centered on swinging fiddle and guitar lines, to draw upon oral history and lay out the lore in French patois lyrics. In 1998 BeauSoleil won a Grammy for folk music. They tour approximately 170 days a year now.

In the early eighties, as Barry Jean Ancelet was compiling his history of the music at USL in Lafayette, the singer-guitarist Ann Allen Savoy, who lives some forty miles away in the town of

Eunice and performs with her husband, accordionist Marc Savoy, was gathering material for her book *Cajun Music: A Reflection of a People.*

"In the past, Cajun music was looked upon with, at best, a certain apathy by the middle classes," wrote Savoy in volume one, published in 1984.

> The music was so alive, so consistently present on the radio and on the dance-hall scene, that it was simply taken for granted. It was just a part of the life intricately interwoven with farming, feasting and entertainment. It was not an endangered species crying out for the help of preservationists; it was not elite; it was not noticed.

> Today, however, it is becoming necessary to turn to the people of the past to again touch home with the original spirit from which the music came. Many musicians are dying and the stories that remain are often changed simply by the amount of time that has passed since the events happened. The simple, unassuming men and women who originally played the music are turning into heroic idols as their life stories grow and explode into exciting technicolor by years of stories passed on. The time is overly ripe to record old memories, and innumerable stories are already buried.

Michael Doucet had his own take on "heroic idols." Born in 1951, he grew up in a family of musicians and singers in the countryside near Lafayette. The singer Zachary Richard, who became a star in French Canada as well as Louisiana, is a cousin of the Doucets'. In the 1970s, Michael spent time in France, teaching English in Alsace, playing fiddle with other Louisiana émigrés. On moving back to Lafayette, he started looking for older musicians, forgotten by the mainstream, trying to piece together lines of narrative from their stories and lyrics. This was central to the discovery of his own artistry.

"Freeman's Zydeco," the third cut on BeauSoleil's 1995 CD, *L'Echo,* pays tribute to Freeman Fontenot, who built the first school for black children in the countryside near the town of Basile and raised his family in the back room of the school. On weekends the school turned into a dance hall for the pioneering Clifton Chenier and the esteemed Creole fiddlers Bois-sec Ardoin and Canray Fontenot. The song has a lilting swing with strings that flow like rocking horns as Michael Doucet sings in sweet harmony with vocals by his brother David, on guitar, and second fiddler Al Tharp:

> On va aller là-bas
> Pour voir Monsieur Zydeco
> On va aller là-bas
> Chez Freeman Fontenot

> Tout le monde dit faudra aller rejoindre
> Pour connaître quoi il a fait avec ses mains
> Il a bâti eine salle de danse et eine école
> Pour tous le voisinage qui est sans nickel

> Il avait des richesses de coeur
> Il est né pour jouer son vieil accordéon
> Il va te donner la chemise de son dos
> Eine grande personne, Monsieur Freeman Fontenot

> We're going out there
> To meet Mister Zydeco
> We're going out there
> To Freeman Fontenot's

> Everybody's going to be there
> To see what he did with his own hands
> He built a dance hall and a school
> For the whole neighborhood that didn't have a dime

> He had riches in his heart
> He was born to play his old accordion
> He'd give you the shirt off his back
> A great man, Mister Freeman Fontenot

"I remember Varise Conner," chuckles Michael Doucet. "The first time I went to his house his wife said, 'He's in the wood cutting down trees.' Mmm-*hmm.* She showed me a trail so I walked half an hour and got nowhere. So I sat on a log and waited. This burly guy comes walking up carrying a cypress log. He says, 'What are you doing?' I told him. He said, 'Well, help me carry a log.'

"So we carried it to his house, where he had a mill; he was sawing the log he had cut into planks, using a blade that must have been six feet tall. We talked all that afternoon, and about six o'clock, after he finished and washed up, he got out the fiddle and said he needed 'some diesel'—meaning Jack Daniels. Then he started playing the music—this burly guy, as big as I am, playing the most gentle and delicate Cajun music, with no remnants of accordion or modern country-western style, really Acadian string-band music which he represented from the era he had played in the '20s and '30s."

BeauSoleil (named after an eighteenth-century leader of the Acadians) made its first recording as a group in 1976 and was off and running.

The group provided the soundtrack for Glen Pitre's film *Belizaire the Cajun.*

As BeauSoleil made records on the Rounder label, Garrison Keillor fell in love with the music and arranged a series of appearances on his NPR program *A Prairie Home Companion.*

"There was never really a pattern for this," says Doucet of the band's success. "In the past, the only way people got out of South Louisiana was to go to Nashville and play country-western, or move to New York or L.A. To have a base here, in Acadiana, while playing traditional music—I guess we are the first to do it; but it wasn't a compromise. . . . What really helped was the food craze, Paul Prudhomme's popularity took off in the mid-eighties."

The men in white hats

Chef Prudhomme's influence on cuisine was as revolutionary as Fats Domino's songs were on rock-and-roll of the 1950s. Born and reared in south Louisiana, Prudhomme as a young chef at Commander's Palace in the Garden District utilized herbs and seasonings that were indigenous to the surrounding area in creating new sauces and recipes. "Prudhomme liberated local cooking," explains New Orleans food and travel writer Gene Bourg, who was for many years the restaurant critic of the *Times-Picayune.* "It's been said that New Orleans was a city of a thousand restaurants and five recipes. That's an exaggeration of course; but before Prudhomme there was little imagination or diversity to the cuisine."

Famous restaurants like Antoine's, Arnaud's, Commander's, and Galatoire's had time-tested menus and signature dishes, like oysters Rockefeller, shrimp remoulade, trout Meuniere, and gumbo. In 1979 Prudhomme opened K-Paul's restaurant in the French Quarter and quickly drew a following of locals and tourists. A long article on Prudhomme by Craig Claiborne in the *New York Times* put him on the national map. Suddenly he was making guest appearances at restaurants on the West Coast and in Manhattan, with four hundred people waiting to get in. The lines at K-Paul's grew longer as well.

"Prudhomme urbanized Louisiana country food," says Gene Bourg. "He made it glamorous."

He also insisted that his cuisine not be called Cajun. Traditional Cajun is farmhouse cooking based on pork, sausage, and seafood, with celery, onion, and Bell pepper that simmer in a *roux,* or sauce made of a thickened paste from flour and oil or butter. Prudhomme's insistence on carefully cultivated vegetables, greens, and condiments, along with his flair for seasonings and culinary creativity—the inventor of soft-shelled crawfish!—achieved a rich flavor of provincial French Louisiana. His genius was in the sauces and spiced combinations for grilling. The signature blackened redfish, for example, is not Cajun cooking, though many restaurants now advertise it as such.

Other chefs soon followed the path Prudhomme forged. Alex Patout, who began his career with an eponymous restaurant in New Iberia, branched out with a restaurant in New Orleans and was profiled in *Esquire* magazine. John Folse promoted a Cajun roots cuisine from his famous restaurant Lafitte's Landing, in Donaldsonville. In 1990 he was named National Chef of the Year by the American Culinary Federation. He prepared the cuisine for President Reagan and Soviet premier Gorbachev during a 1988 summit in Moscow. In October of 1998 a fire destroyed Lafitte's Landing. The following spring Folse reopened at his former home, now known as Lafitte's Landing Restaurant at Bittersweet Plantation.

Emeril Lagasse, who followed Prudhomme as a chef at Commander's, now has a booming business, with the flagship

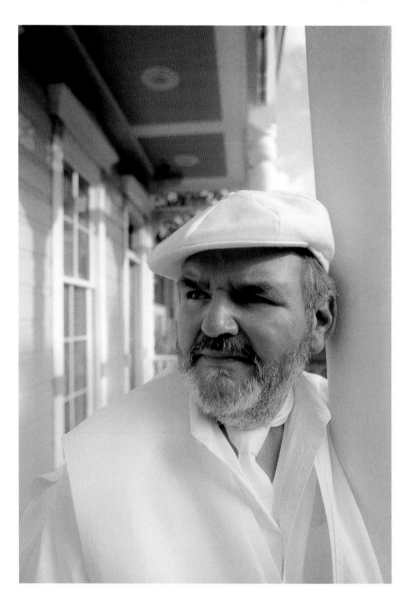

1999 Chef Paul Prudhomme, seen here at his home in New Orleans, pioneered the culinary renaissance in south Louisiana.

2000 Monroe radio personality Sister Pearlee Toliver

Emeril's on Tchoupitoulas Street, two other restaurants in New Orleans, one each in Las Vegas and Olando, a national TV show, and book projects. Emeril may be the ultimate celebrity chef.

Folklife up north

It is often said that the northern parishes, which are traditionally Protestant, have more in common, culturally and socially, with Mississippi, Arkansas, and Alabama than with the *joie de vivre* mentality so apparent in New Orleans and the Cajun and zydeco parishes of the southwest.

This is true, but only to an extent. The woven baskets, sewn blankets, carved figures, and other durable expressions of Indians and backwoods folk, white and black, was a quieter tradition overshadowed for decades by the musicians. That isolation has also ended as the works of folk artists, displayed and sold at

community gatherings, "teach people about the value and beauty of traditions," explains Michael Luster, executive director of the Louisiana Folklife Festival. The festival, held each fall in the city of Monroe, in the northeastern corner of the state, is "especially attractive to our visitors from Arkansas," notes Luster in *Cultural Vistas.* "I lived there for many years and I know that for Arkansans, the mystique of Louisiana begins at the state line. If they learn they can drive just forty miles over the border and see Mardi Gras Indians, zydeco bands, Cajun accordion makers, dance to the blues, eat some gumbo, and hear a story about Huey Long—man, they're here."

Who could blame those action-starved citizens of Arkansas?

Folklife is steeped in religion; it is also rich with comedy. For years now Pearlee Toliver has been spinning out her own offbeat take on life via the radio airwaves in Monroe. The self-styled Jewel of the Dial, Pearlee Toliver reads advertisements in a sing-song accent with a slight speech impediment. Casette copies of her Sunday morning program on KYEA-FM (103.1) have taken on a reproductive life of their own, landing in places like New Orleans, Little Rock, Nashville and the island of Manhattan, winning this good lady an underground fan club including country singer Loretta Lynn, Billy Gibbons of ZZ Top, Austin-based singer and pianist Marcia Ball, cemetery historian Rob Florence, and *New York Times* pop music writer Neil Strauss.

Monroe business owners know that an advertisement on Pearlee Toliver's show is guaranteed the personal touch.

"Bubba Fish market," she exclaims, and then she's off on a riff of simulated dialogue.

"'Hey, girl, what are you gonna have for lunch today?'

"'Oh, I was just thinking about stoppin' in at Bubba. Bubba, he catches *fresh* garfish daily: $2.88 a pound. Buffalo ribs: $2.58 a pound. Buffalo backs: one dollar a pound. Mixed buffalo: three pounds for a dollar.'"

"'*Catfish* filet: $2.58 a pound. *Whole* catfish. Catfish *filet.* Catfish *nuggets.* I want you to know that Bubba will not open the door if the fish is not fresh!'"

And then comes her tagline, with a spoken rhythm like a zipper: "Why-not-check-it-out-and-lock-it-up?"

Gospel music is a large thread in the fabric of her life. In the 1950s she worked as manager of a group called the Jordan Singers. One member of the group, H. P. Gibson, owns the Twin City Record Shop (Monroe and West Monroe are the twin cities of northeast Louisiana) and became an early sponsor of her program. Her show mingles short interviews with locals, often about church activities, with sprinklings of information that give small-town life such character, as when a guest matter of factly

announced Reverend Nobles's 114th birthday amidst a flow of community announcements.

The voice of Pearlee Toliver is an amazing product. As Strauss wrote in a flattering profile in the *Times:* "Words randomly soared and plummeted in pitch, either eliding or coming to a full stop for no semantic reason. Emphasis was given to the wrong syllables, slurred or completely dropped. The second half of some words was often not prounced at all. . . . All these were elements of a radio persona that Ms. Toliver has invented on her own."

Many businesses have found her program a solid investment. No one could script ad copy like this:

"If you want to get out of jail in a hurry, you ask for Diddy Bop. Don't sit there in jail all day and all night with your feet swelling all over your shoes and you worrying and crying and wanting to go home to your family. Call Diddy Bop. Diddy Bop will be there in the next fifteen minutes to get you out of jail."

And then her resilient tag line: "*Why-not-check-it-out-and-lock-it-up?* Movin' on, my Christian friends . . ."

North Louisiana is where the state's populist imagination soared in the 1920s and where pentecostal Christianity thrives today. Jimmy Swaggart as a young preacher traveled the back-roads of the northern parishes and in the early 1970s made the shift from gospel music to evangelizing on television. In the 1920s, Huey Long came out of Winnfield, in Winn Parish, a striking figure on the campaign trail, hands slicing the air like a preacher with sinners to save. He'd hold up a foot, absent the shoe, to show his followers where the big toe protruded through the worn sock, dazzling poor folk drawn to the heat of his presence. He told one crowd, "There is as much honor in the *New Orleans Item* as there is in the heel of a flea."

The achievement of great power in a state where the FBI and federal attorneys have their own history of stalking the high and mighty (usually for pretty good reasons) demands a cast-iron stomach. Sometimes these larger power-presences become fodder for Carnivalia. The photograph taken at a parade in Baton Rouge is a priceless case in point. A young man wears a t-shirt emblazoned with the face of David Duke; he stands sandwiched between celebrants in masks depicting Jimmy Swaggart and Edwin Edwards.

Swaggart, Edwards, and Duke—the unholy trinity!

The Duke t-shirt guy is smiling with appreciation for the red kissmark planted on the forehead of the Swaggart mask, a visual reference to the televangelist's fall from grace.

Jimmy Lee Swaggart, the scripture-throttling preacher whose sermons were beamed across the globe, was pulling in $500 mil-

lion a year until 1988, when his encounters with a prostitute sent his broadcast empire into a free fall. Duke, the former Klan leader with a surgically altered face, moved across the state in the early 1990s promoting himself a newborn Republican and a *pro-life Christian*—this from the man who for years had sold hate literature denouncing Jews. One title was *The Holy Book of Adolph Hitler.*

Edwards, who was elected governor a record four times, cast himself as a populist in the mold of Huey and Earl Long. He was arguably the most entertaining politician Louisiana has ever seen. Long before politicians' sex lives were fodder for the media, Edwards's generated such an oral history that he bragged of being safe with voters unless he was "caught in bed with a dead girl or a live boy."

Elected to a third term in 1983, Edwards was indicted on racketeering charges but acquitted at trial in 1986. As the state's economy foundered, he left office a most unpopular man. In 1991 he mounted a comeback, knocking the incumbent governor, Buddy Roemer, out of the mansion and entering a runoff with David Duke. The so-called "race from hell" put the state under an unenviable international spotlight: the unsavory Edwards, or a white supremacist who had a pathological relationship with the truth. A bumper sticker said it all: "Vote for the Crook. It's Important." Edwards won in a landslide. After his inauguration he rammed a controversial bill through the legislature that brought casino gambling into the state. He retired from office in 1995 and was indicted in 1998 on charges of extortion for casino permits.

Swaggart, Duke, and Edwards were looming shadows in Louisiana's parade of power in the 1980s and 1990s. Perhaps, then, precisely *because* they happened here, those three men at the Baton Rouge Carnival parade seized on their visages, all the better to make sport. Few cultures could turn the persona of a David Duke into a device for humor. Yet Louisiana has a long history of satire in Carnival masking and parade design; the state rolls with body-blows to the democratic psyche that in Maine would be unthinkable, and then, as if pivoting on a dime, serves the worst excesses back to the public in faces such as those of the unholy trinity.

In the autumn of 1999, Edwards was indicted on charges involving the liquidation of an insurance company. In May 2000, he was convicted on seventeen of the casino-related charges; appeals were anticipated as this book went to press. Duke, who has yet to regain public office despite several electoral tries since 1991, became the subject of a federal investigation into his fund-raising practices and said he expected to be indicted.

Coda . . .

In Louisiana, culture and corruption sometimes seem to function cheek to jowl, rubbing against each other like dancers at a ball, partners in a forced marriage, nevertheless putting on a respectable waltz. Each side of Louisiana's divided personality wants so much more. The wealth of artistic expression, like the many festivals that mirror Louisiana's spirit of *laissez les bon temps rouler,* stands out in high relief from the greedy political history, the fallout from which shows in at-or-near-the-bottom rates of illiteracy, infant malnutrition, and child poverty, and correspondingly high records of environmental pollution, in comparison with those of other states.

But these sad markers are not the only gauge of a civilization. Political reporters will continue to swoop down, drawn to the state's excessive power dramas, while those who report on culture and travel will pass through in search of more uplifting interpretations of Louisiana. Between this divide lies a territory of great expressiveness. An older, deeper memory keeps rising from these continental lowlands—a sense of myth and connection that even hard times cannot wash away—channeling the music, stories and images about native land into tidal currents that flow out, relentlessly, into the world.

1992 Participants in the Spanish Town Mardi Gras Parade in Baton Rouge wear the likenesses of Jimmy Swaggart, David Duke, and Edwin Edwards. The parade is famous for its satire and political irreverence. The 1992 theme, "Beneath the Sheets," honored Duke and Edwards, who had just faced each other in a runoff election for governor. The Reverend Jimmy Swaggart had also gained some infamy through various sex scandals.

FACES

1996 Melise Broussard, Rayne Frog Festival queen, kisses a potential prince during the annual festival.

1993 Alligator Annie Miller, seventy-nine, feeds a piece of chicken to "Boomer," a hungry twelve-footer, during a swamp tour south of Houma with a group of Baptist retirees from northern Georgia. Boomer was one of many alligators that Mrs. Miller, who has since retired herself, knew by name.

1989 Alligator farmer Jack Montoucet holds a hatchling on his compound near Duson. Raising gators in captivity has become a big enterprise over the last decade or so. According to a formula devised by the Louisiana Department of Wildlife and Fisheries, alligator eggs are taken from the marsh and incubated on farms. Farmers raise the gators for one or two years, till they are roughly four feet in length, a size achieved much more quickly in captivity than the wild. Wildlife agents then return 17 percent of the farm-raised gators to the swamp (the percentage represents the number that would normally survive to this age in the wild). The rest are sold for meat and skins. "The great beneficiary of the program is actually the marsh itself," according to Dr. Ruth Elsey, an alligator specialist at the Rockefeller Wildlife Refuge in Cameron Parish. "Property owners now have an even greater incentive to preserve the wetlands."

1996 On St. Patrick's Day in New Orleans, parading men exchange the beads around their necks for ladies' kisses.

1997 Clarence Bourgeois and Peggy Beuche dance at the Blues Festival
along the Mississippi River levee in Baton Rouge.

On the appointed day we drive to of the big house in the lower Ninth Ward—far downriver from the French Quarter—where Antoine "Fats" Domino lives. Trimmed in pink and yellow, the white brick house has a lavender roof of Italian terra cotta tiles. The string of recordings he made for the Imperial label in the 1950s has exceeded 100 million sales, producing largess for Domino and his wife, Rosemary. They have four sons—Antoine III, Andre, Anatole, Antonio—and four daughters—Antoinette, Andrea, Anola, Adonica, all now grown.

Half a century has passed since that seismic day in late 1949 when a plump, little-known piano player, discovered by the bandmaster and studio genius Dave Bartholomew, sat down in the back room at Cosimo Matassa's studio and with a rolling Creole baritone belted out those memorable lines: "They cawlll, they cawllll me / the Fat Man / Cause I weigh two / hundred pounds / All the girls they love me / Cause I know my way around."

"The Fat Man" planted Fats Domino on the map of American popular culture. Within five years, as the Supreme Court was overturning segregation in schools, white teenagers across the country were jumping to the pulsing beat and honey-sweet vocals of Antoine's personal hit parade, songs like "Ain't That a Shame" (with the sadness-mocking "yo' tears fell like rain") and the multimillion seller "Blueberry Hill," in which he sings with a country-western lilt, unto the wonderful, punchy tempo on "I'm Walkin'," with Earl Palmer slapping the drumsticks and the fat man singing, "Yessss indeed I'm walkin', till *Yew*-come-back-to-ME!"

He doesn't perform much any more. Gone are the Las Vegas shows, the European tours. With appearances at the Jazzfest, an opening for Harrah's Casino, or a big New Year's Eve gig he has enough to keep the chops in good shape and enjoy the adoration of his fans. He's one of the most beloved men in Louisiana and nobody knows much about him. He's world famous but not really a celebrity. He rarely goes on TV or radio and has turned down interview requests for years. His own version of the good life is taken slow, in the neighborhood of his youth. He passes most of his days in a little shotgun house next door to and dwarfed by the family home. For Fats it's a kind of den, a clubhouse.

Today he's doing a photo session because his friend Haydee Lafaye Ellis, who accompanies the photographer and writer, has recommended that he do so. A finger hits the front door buzzer. Second pass, then a minute, then Antoine Domino himself answers the door.

"Why, Miss Haydee!" he beams with the pleasure of a squire welcoming a lady from some distant barony.

"How's the judge?" inquires Fats of her husband, the retired jurist Frederick Stephen Ellis.

"Judge is fine, Fats. He sends a big hello."

Antoine Domino, who turned seventy-two on February 26, 2000, is portly but otherwise looking good.

Photographer, writer, and Haydee follow Fats through the house, past the Stairmaster and a closet with about a hundred pairs of shoes and a rainbow of suits and shirts and ties, into the kitchen, where a substantial hen is simmering in a pot and cousin Freddie Domino is watching Jerry Springer with two of Antoine's comrades, all them evincing a certain gnarled wonder at what TV is coming to.

"Disgustin'," says one old buddy as the Springer world plays out.

"People do anything," says another, as the young people on the screen scream at each other about betrayal.

Fats Domino, who goes to Mass regularly, studies the screen for a moment and shakes his head.

We follow the host into his dining room. The walls here are valentine pink. A white couch stretches across one wall, with arm cushions supplanted by pink fins of a vintage Cadillac sporting red taillights. Midway up the wall behind the glass table and set of chairs, with handsome table settings, is a huge video screen best viewed from the floor above. Take the stairs up and you come to the bar, set behind a row of chairs, where the guys watch Saints football games and other major events. The bar per se is studded with silver dollars Fats brought home in the trunk of his car in a big sack after a gig in Las Vegas.

Ready to pose, Fats is wearing snow-white pants and matching shoes, a canary yellow coat and turquoise shirt. He is a radiant presence, a man who can still ride that rock and roll train after fifty years in the engineer's seat with an ageless voice so smooth and sweet you'd like to put it in a bottle.

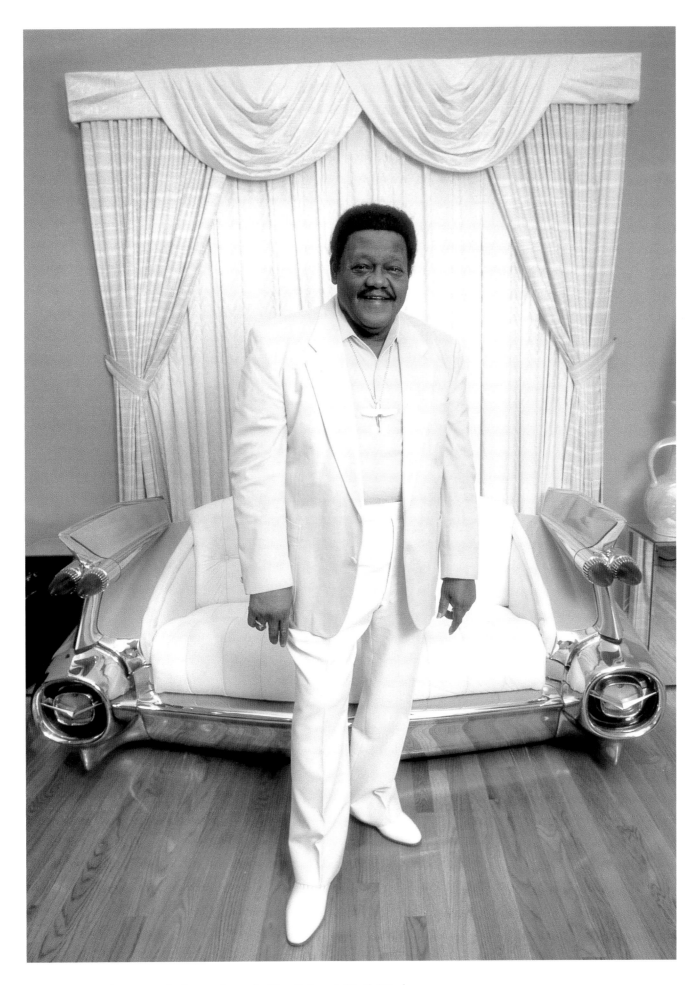

1999 Fats Domino greets the lens at home in New Orleans's Ninth Ward.

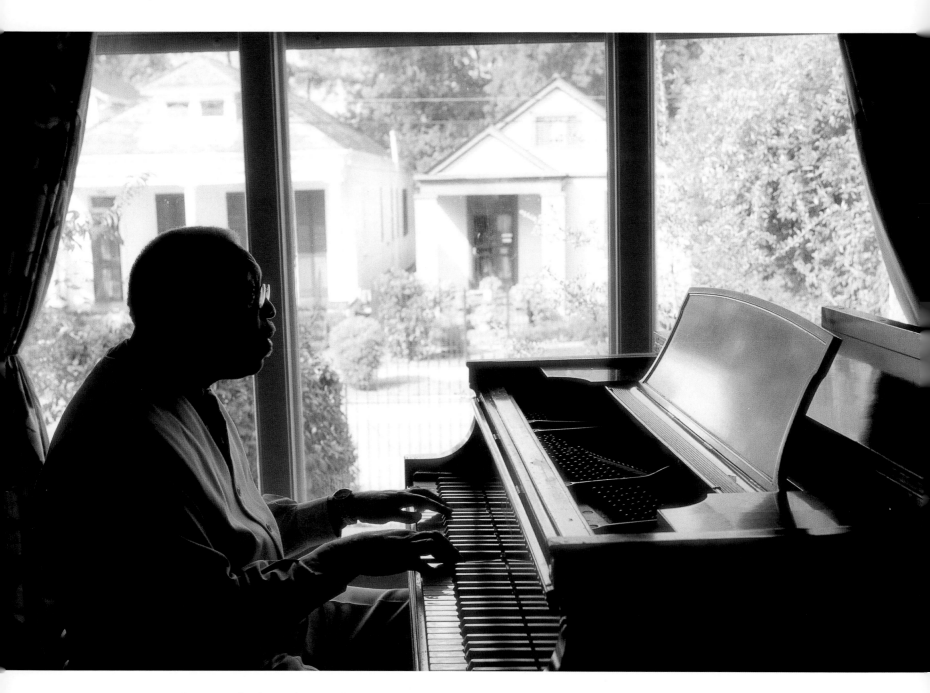

1999 The patriarch of one of America's most illustrious musical families, Ellis Marsalis was a prominent pianist in New Orleans's modern jazz scene of the 1960s and 1970s. He was a founding music educator at New Orleans Center for the Creative Arts, the public high school for gifted students that has produced such distinguished alumni as his sons Wynton and Branford; Harry Connick Jr.; Terence Blanchard; Donald Harrison Jr.; and Nicholas Payton, among others. For the last decade he has held a chair in jazz studies at the University of New Orleans. He performs regularly at the Snug Harbor jazz club. *Loved Ones,* a CD with Branford on saxophone, is one of the best of Ellis's many recordings. Ellis and his wife, Dolores, have six sons, of whom four (including Delfeayo and Jason) are professional jazzmen.

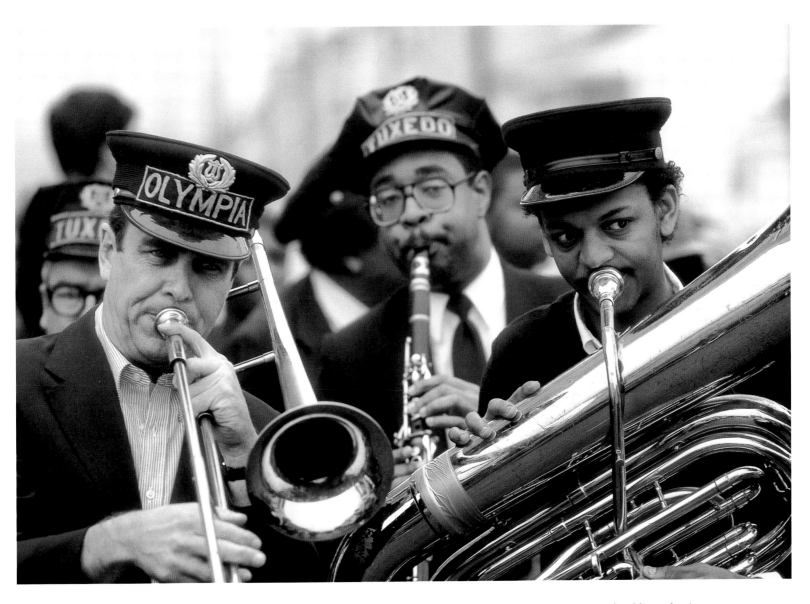

1986 In the century since jazz dawned in New Orleans, brass bands have been playing for all manner of public and private events. Street parades are their staple, a tradition that fuses the European military marching style with the jazz polyrhythms, syncopations, and street dancing of an African memory. Frank Demond on trombone plays with Michael White on clarinet and Lucien Barbarin on tuba in a procession through the French Quarter. Barbarin is a fifth-generation jazzman from one of the city's many musical families. White had cousins on his mother's side, Kaiser and Papa John Joseph, who played in the early 1900s.

1992 Trombone Shorty—Troy Andrews—performs at Café Brasil. Brother of trumpeter James Andrews Jr., grandson of rhythm-and-bluesman Jesse "Ooh Poo Pah Doo" Hill, Troy grew up playing the trombone in the Tremé neighborhood and the nearby French Quarter. His mother, Lois, operated a music club for several years called Trombone Shorty's, after his nickname.

Eddie Bo Paris of the Chosen Few Marching Band cranks it up during a Sunday street parade, an almost weekly musical occurrence in New Orleans.

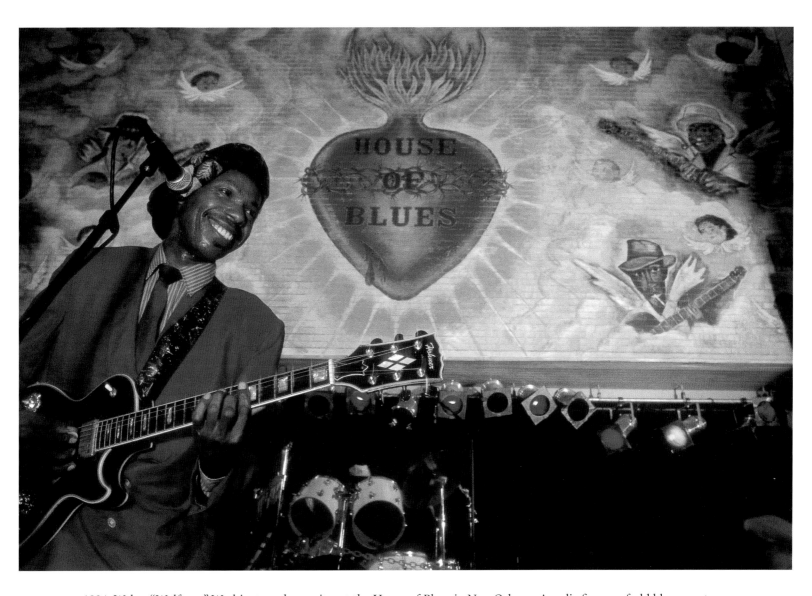

1994 Walter "Wolfman" Washington plays guitar at the House of Blues in New Orleans. Angelic figures of old blues masters float in the sky on a painted backdrop behind him.

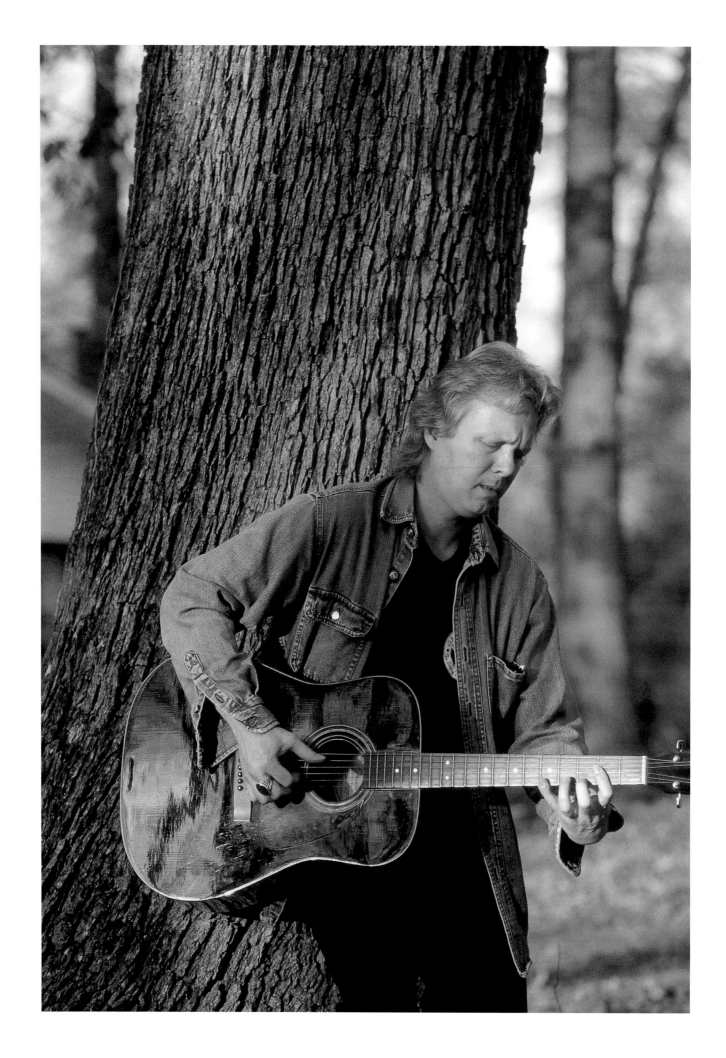

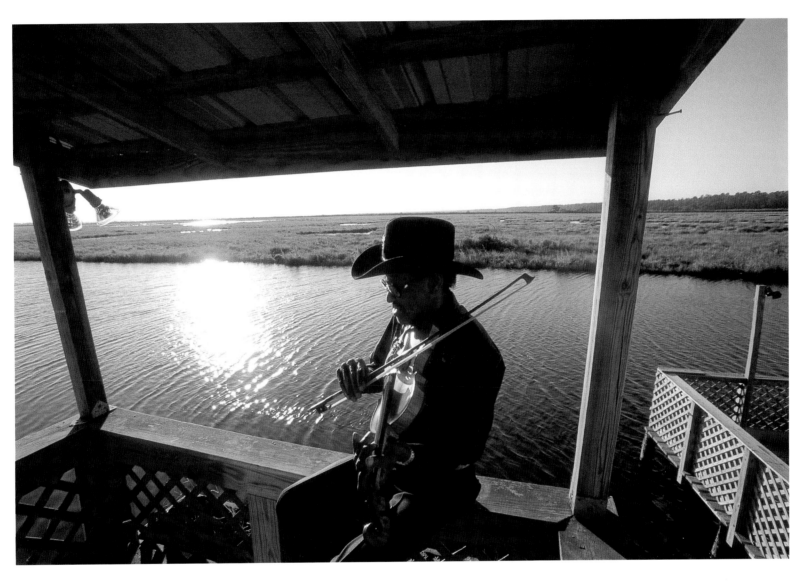

1999 Bluesman Clarence "Gatemouth" Brown enjoys a sunset over the marsh while playing fiddle on his back deck at home in Slidell.

2000 Rockabilly-blues-country singer Kenny Bill Stinson picks a tune at his home in the piney woods near Downsville. Out on the road he performs with his band, the Ark-La-Mystics.

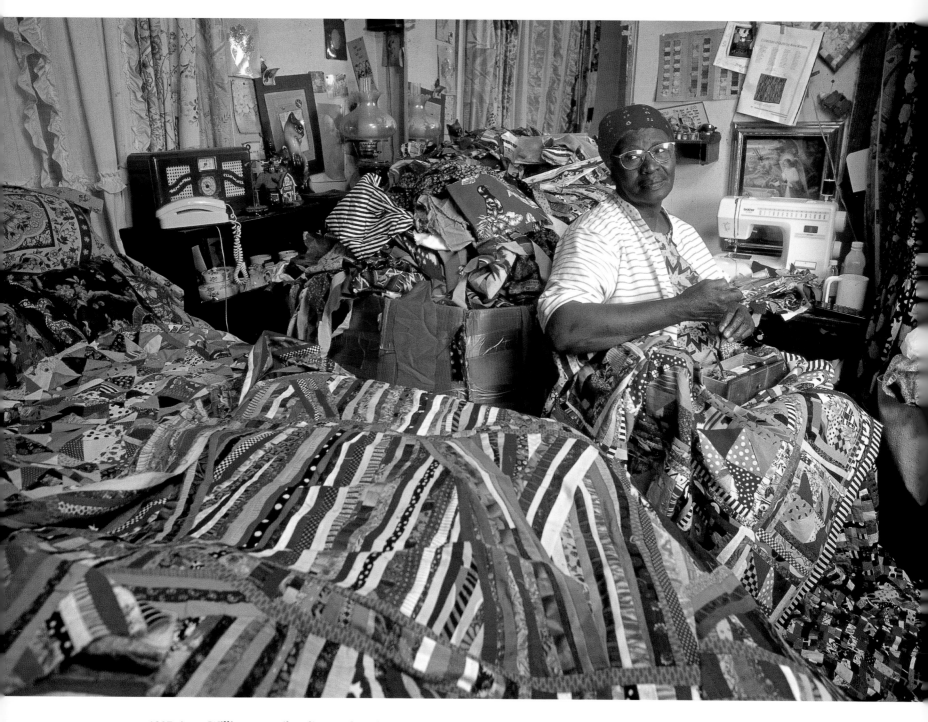

1997 Anna Williams, a quilter, lives and works in her home in Baton Rouge.

1990 "Mama" Lair La Cour holds portraits of her parents Laocadie "Cadie" and Vigar Dominique Sylvie at her home in the Isle Brevelle community on Cane River south of Natchitoches. Mrs. La Cour is a leader, if not the unofficial grandmother, of the community of Creoles of color who have made this rich farmland their home since the late 1700s; she is also a quilter and doll maker. Mama Lair is descended on both sides of her family from Augustin Metoyer, a planter who headed the community throughout most of the antebellum nineteenth century; he was the eldest son of the remarkable Marie Thérèze, a slave who gained freedom for herself and her ten Metoyer children, named for their white merchant father, Pierre Metoyer.

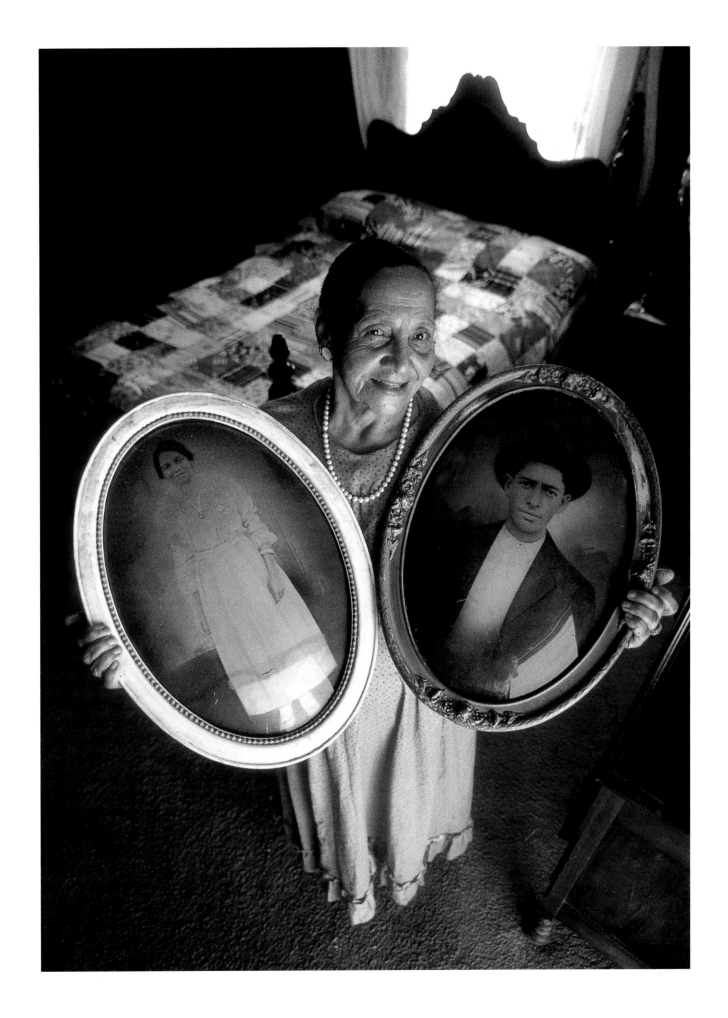

1998 Raymond Thomas, a Chitimacha basketmaker, displays some of his work at the tribal fire station in Charenton. Chitimacha basketmakers enjoy a national reputation for their design and workmanship. Thomas is also a volunteer fireman.

1998 Lorena Langley, a Coushatta tribal elder and basketmaker, holds one of the first pine cone turkey baskets she made as a child near her home in Elton.

1980 A young Houma Indian paints a Lafitte skiff–style fishing boat near his house in Dulac.

1998 Rose Blasingame presents some of her craftwork while daughter
Anna Barber, a Jena Choctaw tribal princess, stands next to her. The
setting is near their home in Jena.

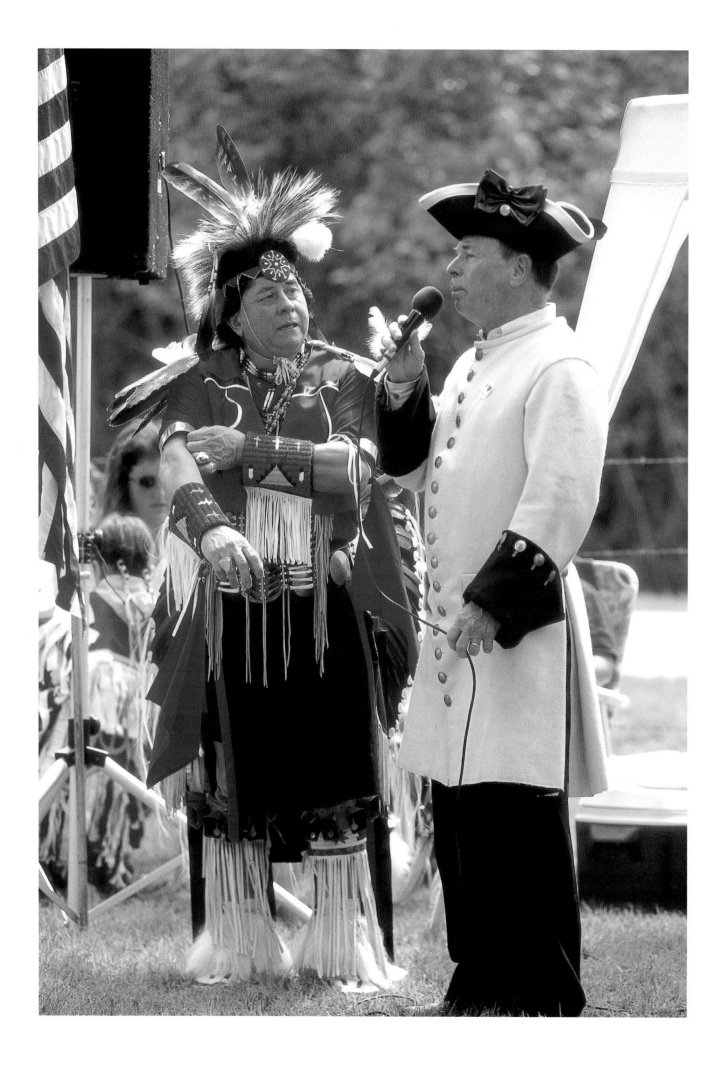

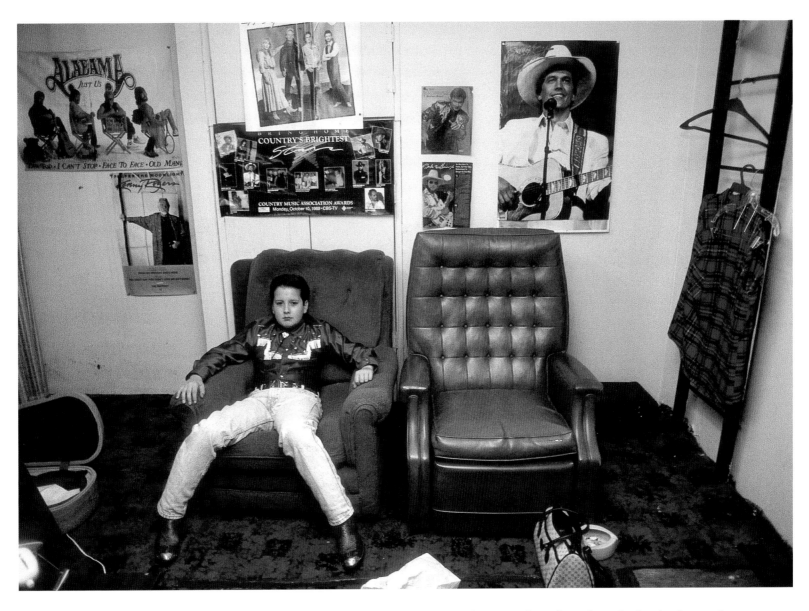

1991 Echoing the dreams of Elvis Presley, Jerry Lee Lewis, and countless other young boys throughout the South who sought fame via the song, B. J. Cobb rests backstage while waiting to perform at the Dixie Jamboree radio show in Ruston.

1998 Caddo Adai tribal chief Rufus Davis welcomes Natchitoches mayor Joe Sampite to a powwow in Robeline, a nearby community. Sampite chose to dress in colonial costume for the occasion. After the mayor's talk, the two "broke bread" with a ceremonial eating of Natchitoches meat pies.

In the summer of 1999, Valerie Martin's sixth novel, *Italian Fever,* received page-one praise in the *New York Times Book Review.* Six months later, Christine Wiltz published her fifth book and first work of nonfiction, *The Last Madam,* a biography of Norma Wallace, who operated a legendary New Orleans bordello for forty years. Val and Chris have been best friends since 1979. Their children, Adrienne Martin and Marigny Pecot, are best friends who grew up together. The writers met through Rhoda Faust, proprietor of the Maple Street Book Store, itself something of a New Orleans literary institution.

Chris: "The only writer I knew at that point to really speak to was Walker Percy. Whenever I was in his presence there were too many people around who were in awe, and no chance for a real conversation. Marigny was three and Adrienne was four. I had a kid and all of my friends had their children later. I was a lonely writer and a lonely mother. Rhoda told me about this writer who had two novels out. I invited Val and Adrienne to the house one day."

Val: "It was a hard period. I was separated, working full-time at UNO and I had a kid. When Rhoda told me she wanted me to meet her friend I didn't think it was a good idea, because I didn't have time. But we hit it off."

Chris: "My husband, Joe, was working offshore a lot in those days. I was in a caretaker mode; one elderly relative after another was getting sick and dying. It was tough. Val was struggling to make ends meet and we were both trying to write, and raise these daughters. I had a station wagon. We'd ride around with the kids in the back seat and listen to them talking. We gave them tape recorders for Christmas one year and we'd try to keep our laughter down—they were mirroring what we did, playing 'let's pretend.' . . . That friendship was crucial. It got me through a lot of hard times."

Val: "One night when Joe was home, he agreed to keep the kids. Chris and I went to the French Quarter, parked around Jackson Square. We went to music places and wound up at the Dream Palace over in Faubourg Marigny, and stayed there till 3 A.M. We were too tired to walk back so we sat on the curb, waiting for the bus. That's when Chris said we bonded."

In the summer of 1988 they spent a vacation on Sanibel Island off Florida's west coast. While there, Chris's agent called with news of a contract for her detective novel *The Emerald Lizard.* The happy news did not dispel her frustration at the slow pace of work on the novel that became *Glass House.*

"Val was writing up a storm on the front porch overlooking the ocean, and I was not writing up a storm in the dining room. I'd see her out there just pouring it out, she'd do three pages and I'd get a paragraph. I'd rant and rave. She'd laugh, then make key lime pie and feed us all night."

Valerie Martin left New Orleans in the mid-eighties for a teaching position in Alabama, and later at Mt. Holyoke. With the commercial success of her novel *Mary Reilly,* she moved to Italy for several years, during which time she and Chris corresponded frequently via fax machines. Living now in upstate New York, Valerie has had several writer-in-residence positions, including the 1998–1999 term at Loyola of New Orleans. The author who followed her in that position was Christine Wiltz.

They visit several times a year.

"I never feel like she's very far away," says Chris. "We talk on the phone at least once a week. The girls email each other and talk on the phone. We've stayed very close in spite of the miles."

Would they be such close friends if they weren't both writers?

"Maybe," chuckles Val. "I think our personalities are complementary and we might have been girlfriends anyway. But so much of the time we spend together is spent talking about writing or the business end. I don't think Chris would be happy if she wasn't writing, and I know I wouldn't be; so if one of us was not writing she'd be miserable and we wouldn't be friends."

"We write very different kinds of books," reflects Chris. "Yet we're always laughing, because no matter what we're working on there's a parallel. As I was finishing a biography of Norma Wallace, she was working away on St. Francis of Assisi. Saints and sinners, where you find one you always find the other."

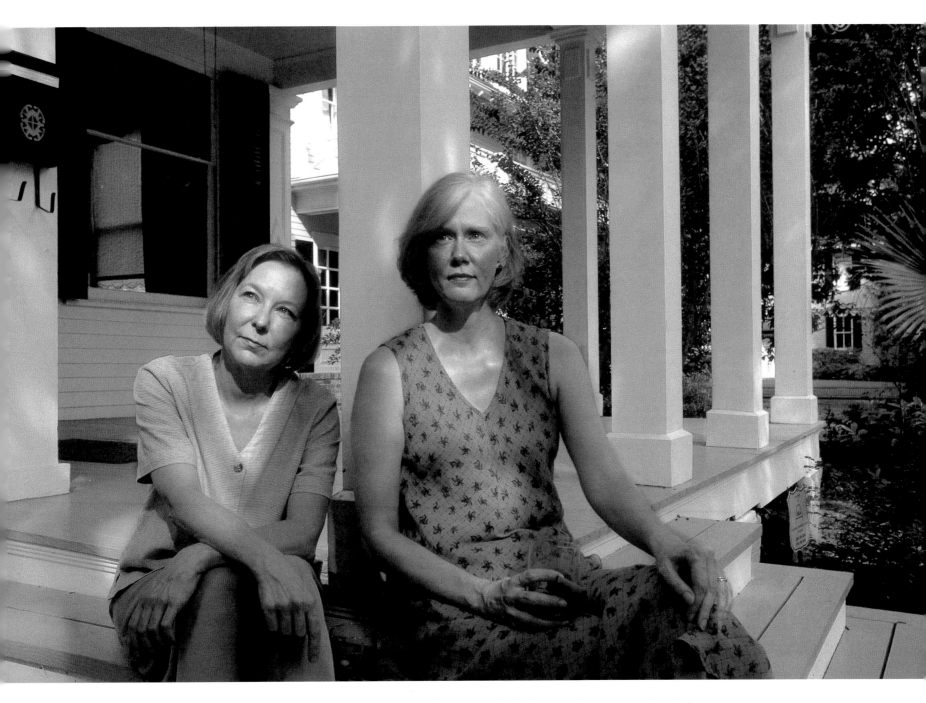

1999 Valerie Martin and Christine Wiltz, writers and soulmates, on Chris's front porch in uptown New Orleans.

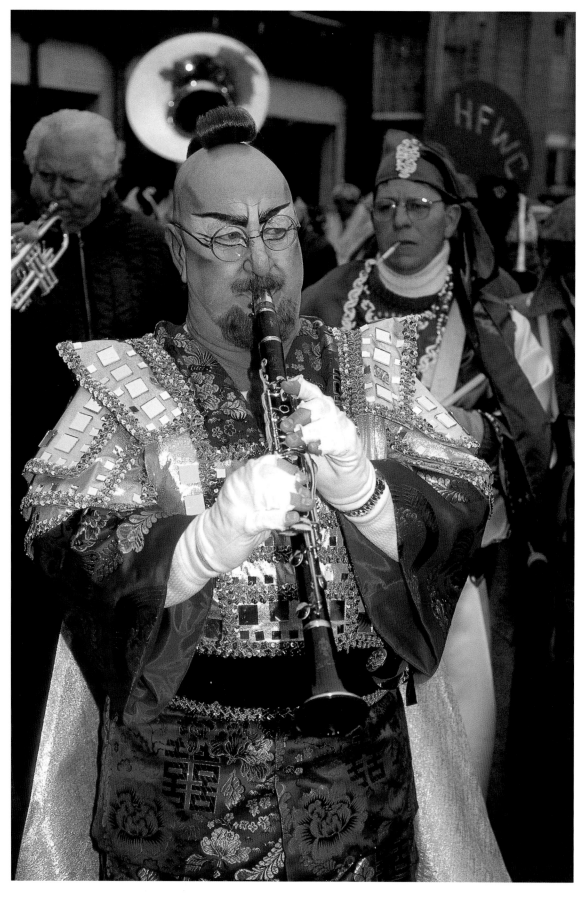

1989 Famed clarinetist Pete Fountain, in elaborate costume, leads his Half Fast Marching Club, Mardi Gras Day, New Orleans.

1997 Darnell "Teddy" Bridges of the Official Gentlemen Steppers parades on the Fairgrounds during the New Orleans Jazz and Heritage Festival.

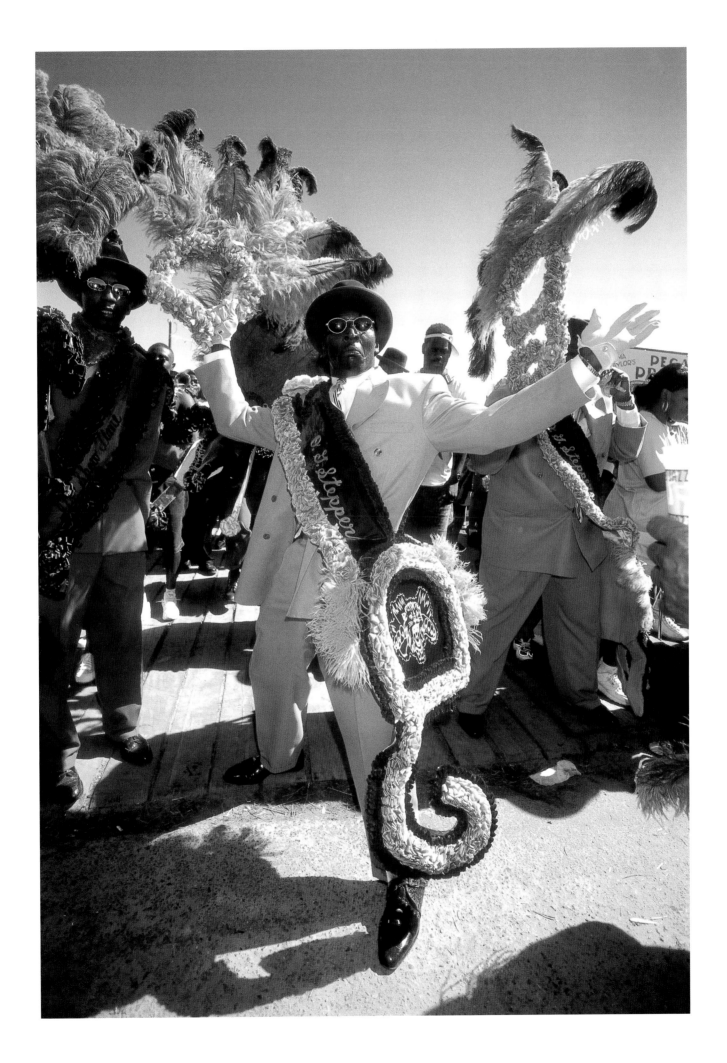

1999 Members of Kumbukua Dance and Drum Collective, a New Orleans–based theatrical dance company that celebrates African culture, perform at the Festival International de Louisiane in Lafayette.

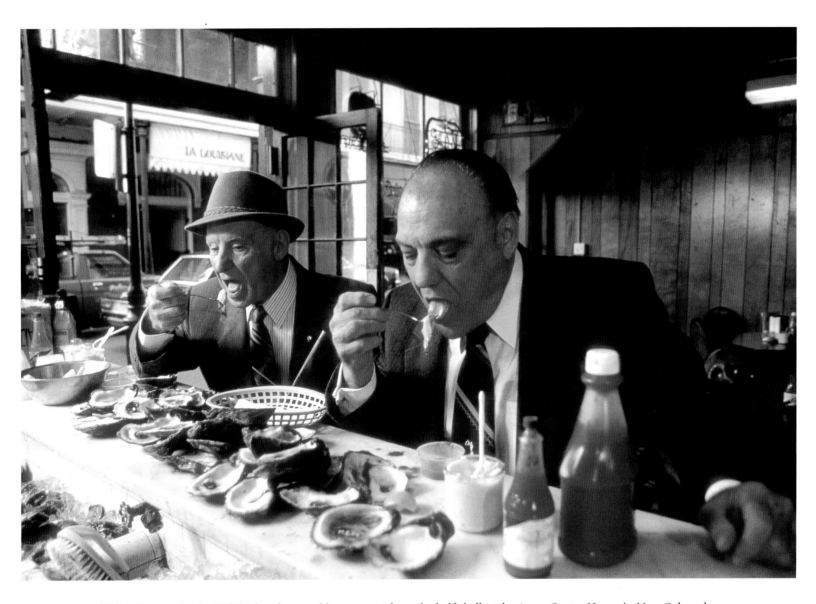

1986 Frank and Charles Cabibi, brothers and lawyers, eat from the half shell at the Acme Oyster House in New Orleans's French Quarter. "I've been coming here since I was twenty-two, about forty years ago," boasted Charles at the time.

1990 Chef Emeril Lagasse welcomes diners to his then newly opened flagship restaurant, Emeril's, in New Orleans's warehouse district. In the last decade Lagasse has established a number of other restaurants in New Orleans, Las Vegas, and Orlando.

1999 Chef John Folse stands in front of his revivified restaurant, Lafitte's Landing at Bittersweet Plantation. The building, located in downtown Donaldsonville, was Folse's home for many years.

In 1933, a nineteen-year-old fiddler named Luderin Darbone, whose family had moved from Texas to the southwest Louisiana town of Hackberry, found a twenty-three-year-old neighbor, Edwin Duhon, who played guitar. The two began trading musical licks, and an association began—the Hackberry Ramblers, a band whose core personnel had made music continuously for sixty-seven years as the twentieth century expired.

Hackberry lies in a corner of Louisiana's oil patch, a region and culture that stretches well into Texas. "In the oil fields in those days there was no one that played instruments," Darbone reflected in a 1994 interview, when he was eighty. "I started playing by ear. . . . My folks would get me some records and that way I was able to learn some of Jimmie Rodgers's numbers." The more lasting influence was the western swing style of Bob Wills and the Texas Playboys. The Hackberry band began as a string trio, adding members as they gained momentum.

The Ramblers' early popularity was driven by radio stations in Lake Charles, Beaumont, and Port Arthur that showcased 78-rpm discs. From the dawn of rural electrification in the thirties through the moon landing of 1969, the collapse of the Berlin Wall, and two presidential impeachment proceedings, the Hackberry Ramblers played on. More than seventy musicians moved through the group as it grew into a seven-piece band with an eclectic, mostly Cajun-and-country bag of songs.

Luderin Darbone and Edwin Duhon saw the seasons come and go. In the 1930s they were a hot item in rural clubs and halls in the oil patch, including some areas where only French was spoken. In that decade alone they recorded dozens of singles. In all, they made more than 100 recordings for the RCA-Bluebird label, about evenly divided between lyrics in English and in French. By 1963, as rock music revolutionized the recording industry, the Ramblers were still playing, but recording work had dried up. Despite the resurgent popularity of Cajun music in the 1970s, the Ramblers struggled to find a niche. But fickle attitudes of popular taste made no difference to Luderin Darbone, who kept on playing the fiddle and leading his band, which held open a spot for Edwin Duhon when he wasn't working on oil-drilling operations in Latin America. Most of the band members had day jobs.

The Hackberry Ramblers kept on rambling, performing songs with the honky-tonk country lyrics mingled with Cajun patois tunes. Glen Croker, the lead singer and electric guitarist, was pivotal to the band's modernization. The percussive flavor of his strings and vocal phrasings, seasoned by R&B and country idioms of the postwar era, bridged the musical generations. In the 1980s, as Cajun music surged into a national spotlight, the Ramblers found a showcase at the New Orleans Jazz and Heritage Festival, and frequent work at the Liberty Theater in Eunice, venues that boosted their popularity with younger fans.

In 1987 a young drummer and music writer named Ben Sandmel, who had moved from Chicago to New Orleans, joined the band, and soon became the manager. A folklorist and producer, Sandmel brought the group into the studio for *Cajun Boogie,* a 1994 CD, their first release in thirty years. Guest artists on the disc included progressive-country musician Rodney Crowell and fiddler Michael Doucet of BeauSoleil.

Ben Sandmel also does the booking, which isn't always easy with two men in their eighties, another in his seventies, and a group that prefers to travel by car. With the 1997 release of *Deep Water,* which includes guest appearances by Marcia Ball and Jimmy Dale Gilmore, the Hackberry Ramblers were nominated for a Grammy in traditional folk music. This necessitated plane trips to New York for the ceremony. Though they didn't win, performances in Manhattan energized the group. They have recently appeared on *MTV Live, Entertainment Tonight,* and *CNN Showbiz Today.*

On December 4, 1999, the Hackberry Ramblers achieved a new pinnacle by performing at the Grand Ole Opry in Nashville. At a special ceremony, Luderin Darbone donated a fiddle to the Country Music Hall of Fame.

1993 The Hackberry Ramblers serenade a passing towboat on the Calcasieu River near Lake Charles.

1999 Marc Savoy leads a jam session of Cajun music on the front porch of John and Jane Vidrine during a party at their Acadian-style house near Mamou.

1993 At a friend's home in Grand Coteau, Bruce Daigrepont plays his daughter Katie Jean a Cajun song he penned for her.

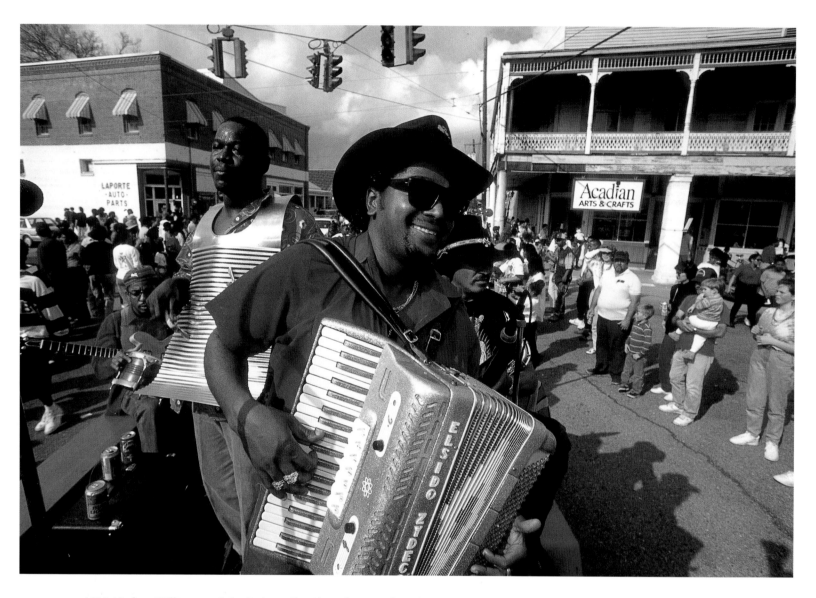

1993 Nathan Williams and the Zydeco Cha Chas play on a float during a Mardi Gras parade in St. Martinville, his hometown. At a young age, Nathan moved to Lafayette and started playing at his brother Sid's landmark zydeco club, El Sido's.

1991 Creole fiddler Canray Fontenot at home in Welch.

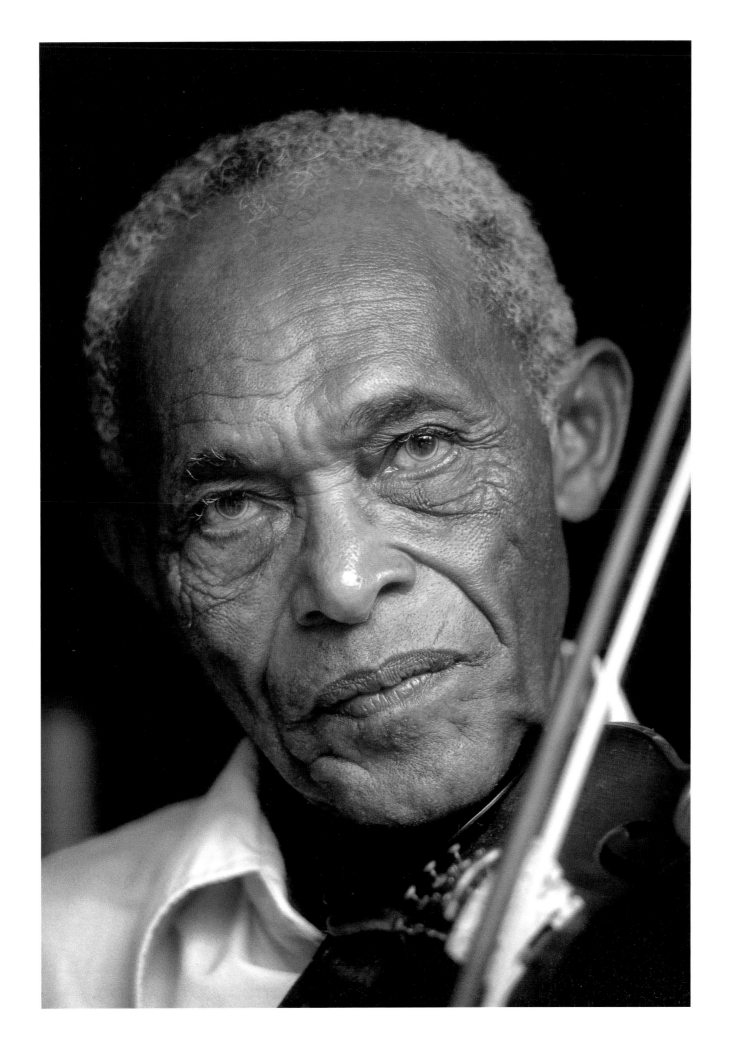

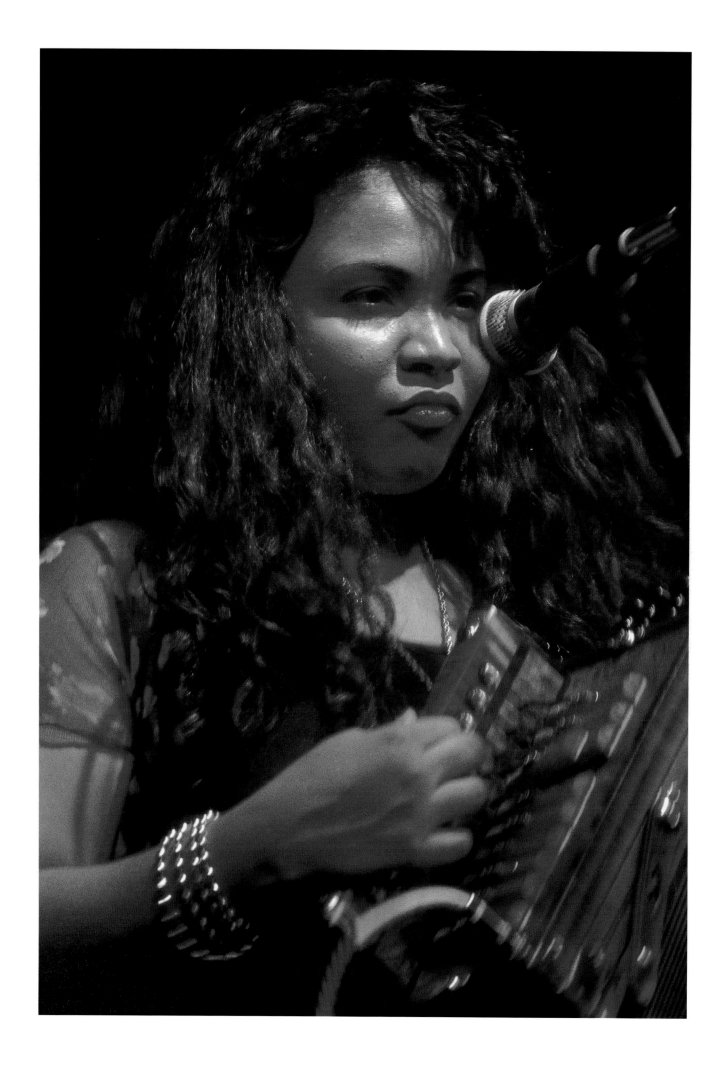

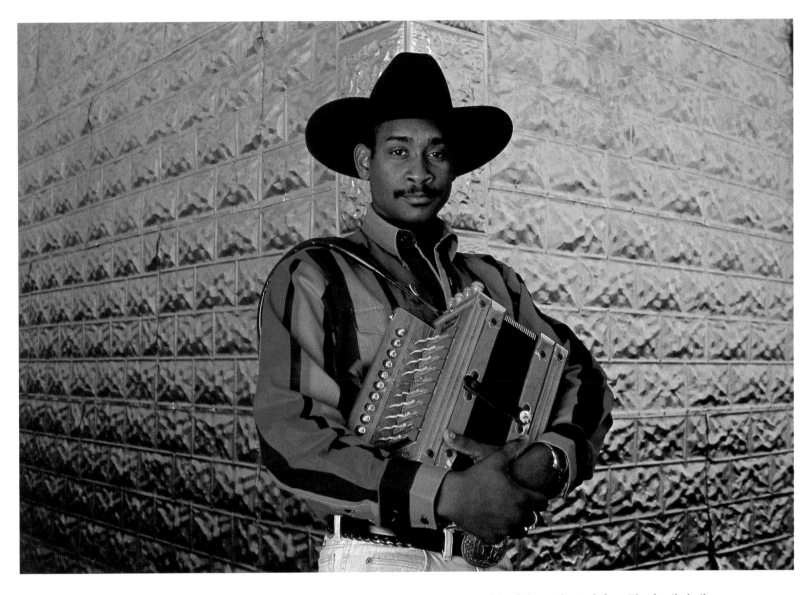

1994 Geno Delafose begins a stellar career in zydeco, following the footsteps of his father, John Delafose. The family hails from Eunice.

1998 Rosie Ledet performs a lusty style of zydeco at the Cajun Crawfish Festival in Fort Lauderdale, Florida.

New Orleans mayor Marc Morial and television reporter Michelle Miller exchanged marital vows on September 11, 1999, before a packed gathering at St. Louis Cathedral. The bride, who grew up in California, was a bit edgy when they began dating—so much potential for conflict of interest!—that she checked with the high command at WWL TV to make sure she wouldn't jeopardize her job. The station arranged her assignments so she would not have to report on City Hall or the administration.

The century's only previous mayor of the city to marry while in office was Robert Maestri, a stolid, forty-eight-year-old bachelor who in 1938 tied the knot with thirty-three-year-old Hilda Bertoniere, who had been his secretary since she was eighteen. The service was just the two of them and the archbishop. The couple moved in with Maestri's mother. Maestri's place in history was secure by virtue of his famous comment to President Franklin Roosevelt over oysters Rockefeller at Antoine's Restaurant: "How ya like dem ersters?"

No such linguistic butchering from the old town's millennial mayor, an Ivy Leaguer (B.A., Economics, Penn) with a law degree from Georgetown. Like all servants of the public, he drifts into a vernacular of the wards, as when he kept saying "on tomorrow" at the wake of a gospel singer.

Marc Morial was born for politics. His daddy, the late Ernest "Dutch" Morial, was the city's first African American mayor, a shrewd, tough, Napoleonic figure who relished the trench warfare of politics as practiced in latitudes such as these. He also had one of the largest jazz funerals in the city's history. Like father, sometimes like son: Marc is shrewd and tough, without the old man's edge. His mom, Sybil, enjoys a near-celestial popularity along with the city's former congresswoman and now Vatican Ambassador, Lindy Boggs.

Mayor Morial and the First Lady are pictured emerging from the church in a shower of light. Concelebrants of the service were Rev. Harry Thompson, the president of Jesuit High School in Marc's student years, and Andrew Young, a minister, former UN ambassador and mayor of Atlanta, and friend of Dutch Morial's. The couple was en route to a massive reception at the Ernest N. Morial Convention Center. A cast of thousands, holding coveted invitations, waited to celebrate. The band played on.

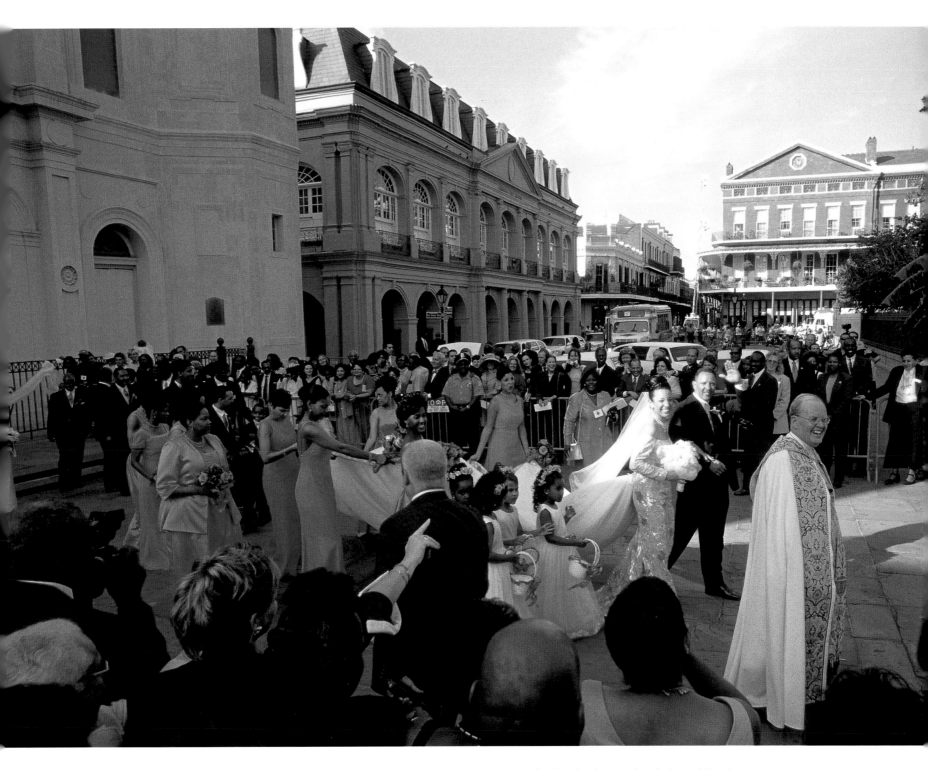

1999 Groom Marc Morial and bride Michelle Miller walk to Jackson Square for family photos after their wedding in St. Louis Cathedral.

1994 Former governors Buddy Roemer, Dave Treen, and John McKeithen discuss politics at the grand opening of the renovated Old State Capitol in Baton Rouge. McKeithen was in fine form that evening and over the course of the symposium reduced his colleagues to the status of straight men.

1997 Governor Murphy J. "Mike" Foster leads the Rough Riders Ride-In, a charity motorcycle ride from the State Capitol to Angola State Prison.

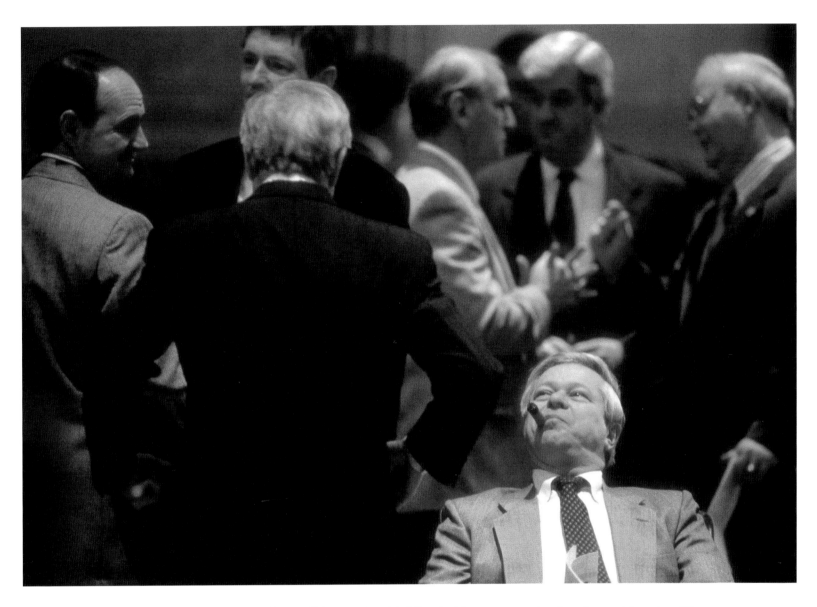

1992 State Representative Jimmy Dimos of Monroe sits with fellow legislators on opening day of a special session. Dimos, who came to America as a refugee from the part of Communist-controlled Yugoslavia that is now Macedonia, was regarded by many of his colleagues as one of the straighter arrows in the body. He now serves as a district judge in Ouachita and Morehouse Parishes and still loves cigars.

1987 Elected to the United States Senate at the age of twenty-nine, Russell Long served thirty-six years, retiring in 1986. Here, he sits in his office in the Capitol during a 1987 television interview, shortly before his departure. A powerful force on taxation issues, he is also the author of the legendary quip: "Democracy is like a raft—your feet get wet, but you never drown."

1983 "I've come to heal this state," cried Edwin Edwards at a rally USL's Cajun Field in Lafayette as family, friends, and supporters gathered around him on the eve of his third election as governor.

1986 "Welcome to Big Mamou Governor Edwards" proclaims the sign over the Holiday Lounge, a bar just outside Mamou owned by "Tee" Ed Manuel, a friend and admirer of the governor's.

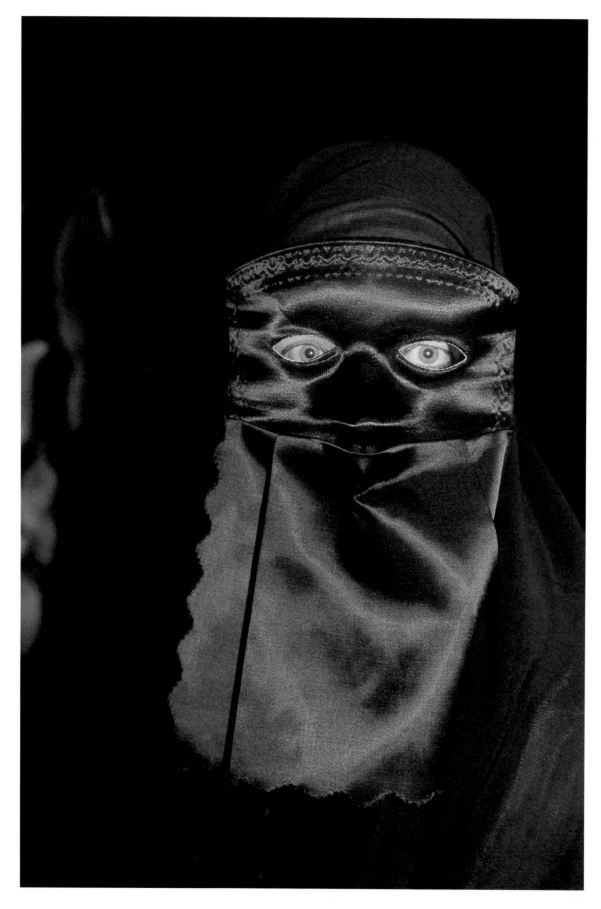

1994 Tina Freeman in the Krewe de Vieux parade during Mardi Gras in New Orleans.

1991 Coe Dupuis is a retired moonshiner who lives in the rural community of Nina, near Henderson. He began making whiskey in 1928 at the age of twenty-five after learning the basics from Kentuckians who were building power lines through the Atchafalaya Basin. He kept on after Prohibition ended, his stills hidden deep in the Basin. He claims he often wanted to stop, but too many people, including local public officials in St. Martin Parish, begged him to continue.

Tim Gautreaux has taught literature and writing for many years at Southeastern Louisiana University in Hammond. His novel, *The Next Step in the Dance,* and two short-story collections have moved him to the front rank of southern writers. Gautreaux's fiction has been published in *Best American Short Stories* and in *Harper's,* the *Atlantic, GQ,* and other leading magazines.

A native of the region, Gautreaux writes of the hard conflicts that beset ordinary folk and how people struggle in search of redemption in their lives. His work summons natural comparisons with the stories of Flannery O'Connor. Catholicism, as a spiritual and institutional presence, runs deep in Gautreaux's work. Machines are also a steady presence in his fiction.

"I see it as a parallel to Catholicism—the possibility of fixing things," he told Christina Masciere in a March 1998 *New Orleans Magazine* interview.

"I collect antique machinery, so I relate to that. Part of it is genetic: My father was a tugboat captain, and my grandfather was a steamboat chief engineer. My great-uncle was a master mechanic. Machinery has a particular metaphorical function, and sometimes I'm working with it a little bit obviously, but most of the time it's subconscious. My wife says I write fiction as an excuse to write about machinery. . . . I do lots of things; writing is one of them. Ambition has never been my long suit, and that's one thing that marks me as a Louisiana native. It's nice that the appreciation of what I do as a writer happens. Yet if nobody ever published any of my stuff, I would still write."

From the title story in his 1996 collection, *Same Place, Same Things:*

> Later that night he lay in his bed with the window open, listening to the pump engines running out in the fields, which stretched away on all sides of the tourist court for miles. They throbbed, as delicate as distant heartbeats. He could tell which type each was by the sound it made. He heard an International hit-and-miss engine fire once and then coast slower and slower through several cycles before firing again. Woven into that sound was a distant Fairbanks Morse with a bad magneto throbbing steadily, then cutting off, slowing, slowing almost to stillness before the spark built up again and the engine boomed back alive. Across the road, a little McCormick muttered in a ditch. In the quiet night the engines fought the drought, popping like the musketry of a losing army. Through the screen of his window drifted the scent of kerosine exhaust.
>
> He thought of the farmer's widow, and finally admitted to himself, there in the dark, that she was good-looking.

1999 Tim Gautreaux, novelist, outside his home near Hammond.

1993 Max Kelley and George Wyatt, two unofficial promoters of downtown Winnfield, pass the time of day outside Kelley's hardware store. Sadly, Kelley died the following year.

1995 Doris and Rodney Stokes hold plants at their nursery in Forest Hill. The area has become a major center for wholesale nurseries like the Stokeses'.

1996 Employees of the Worthmore Store in Rayne hold samples of merchandise for sale.

1983 Armand and Anita Dinette watch television in their home in Grand Bayou, a marsh community near Port Sulphur in Plaquemines Parish. The only access to the area is by boat. No roads reach the houses and camps that run along a bayou in the delta marsh.

1999 Zeb Mayhew Jr. leans against a pillar of the world-renowned Oak Alley Plantation home, built 1837–1839 along the Mississippi River near Vacherie. As administrative director of the Oak Alley Plantation Foundation, he has managed the house and grounds, with their famous quarter-mile-long double row of twenty-eight live oaks, since 1976. The origin of the tree rows is a mystery. They are believed to have been planted in the early eighteenth century by a now-unknown French colonist. In 1836 Jacques Telesphore Roman acquired the property and immediately set out to build a house for his new bride, locating it fashionably at the end of the *allée des chênes*.

2000 Naomi Marshall in front of Madewood, near Napoleonville. Mrs. Marshall, a longtime international businesswoman and champion of the arts, purchased the home in 1964. "I wasn't looking to buy a plantation at all," she remembers, "and the house was in great need of restoration." The Greek Revival home, built in the late 1840s, has been a country inn serving elegant dinners and breakfasts to guests since 1983.

1999 Walter and Lucy Parlange stand in front of their home at Parlange Plantation with two of their children, Angèle and Brandon. Facing False River in Pointe Coupee Parish, the brick, cypress, and bousillage house dates to the late eighteenth century and is one of the finest surviving examples of French colonial architecture in the United States. Marquis Vincent de Ternant, Damvillers sur Meuse, started the plantation in 1754. It was passed down to his Parlange descendants and has remained in the family ever since. Parlange is still a working plantation raising sugarcane and cattle. Walter Parlange Jr. has lived there all his life except during World War II, when he was a decorated B-17 bomber pilot. Miss Lucy came to Parlange as a bride in 1951 from New Orleans. Angèle is a fabric and furniture designer. Brandon is a civil and marine engineer and supervised a major preservation of the house in the early 1980s. Another son, Walter Charles III, is a Houston attorney. *Parlange* translated means "by the angel."

1997 Baton Rouge–based architect A. Hays Town stands at his side door with Josh, his German shepherd. Town revolutionized Louisiana residential architecture by steering design back to the state's traditional styles.

1981 At 7 A.M., three Café du Monde waiters relax before morning customers arrive for café au lait and beignets at this famous French Quarter establishment.

1998 Townspeople carry baskets of eggs through downtown Abbeville for the town's Giant Omelet Festival. Dozens of chefs from Abbeville and France cook the eggs on a twelve-foot frying pan over a fire in front of the Vermilion Parish Courthouse. In a gesture of populism, the chefs pass out free samples of the finished omelet with French bread to all who gather to watch the event.

Nilo Lanzas left Nicaragua as a young man in the 1950s and settled in New Orleans. For thirty-eight years he was a waiter at a downtown restaurant. In the late 1980s, Nilo and his wife, Berta, launched a sideline business, a store at 4138 Magazine Street called Antiquities, where they sold furniture and collectibles. When the restaurant went under, the store became Nilo's full-time job. On September 11, 1993 (Berta's birthday), he began to paint. Week by week the store's traditional stock began losing ground to the flood of paintings, woodcarvings, and dioramas sprung from the imagination of a self-taught, or folk, artist. In the first three years he sold 385 pieces. His work is included at the National Gallery of Outsider Art in Baltimore.

Lanzas sells his art directly out of the store that he and Berta operate, with help from their daughter, Mina. Among those who have purchased Nilo's work: The late Gene Siskel, the film critic; and Susan Sarandon and Tim Robbins, who wandered in while on location for the film *Dead Man Walking* (which he directed and for which she received an Academy Award as best actress.)

Lanzas's pictures are part of a realm he calls Niloville. He carves on small pieces of wood and paints with oils on castoff doors, window frames, and mantelpieces. His subject terrain encompasses the life and death of Jesus; weddings; funerals and baptisms in a semi-African rural South; bullfights, rodeos, and bars; nature scenes with wildly expressive snakes and animals with teeth; undersea sequences of fish and people who are half fish—as well as his personally stylized versions of jazz funerals and New Orleans street parades.

There is not a great quotient of subtlety in Nilo's bursting reds, buttery yellows, slapstick ideas of comedy—it's all up front. The sense of human movement melds a quality of outdoor festivals with a small-town Latin American ambience. The eye alights on a scene of rural black folk, beneath a vibrant blue sky, heading for church: *Wedding in Niloville.* Behind the church, a large hill reaches toward the sky, drawing the viewer out of the conventionally southern milieu: plantation communities don't have mountains.

"It's a volcano," smiles Nilo, redolent of garlic. A balding chap with a rope of hair tied in a pony-tail, he wears paint-splotched jeans and speaks in a humming, slightly amused monotone: "We did not have black people on my father's dairy farm in Nicaragua. But the land looked like that."

Grafting remembered landscapes onto an imagined black community is one distinctive trait of the tiny universe called Niloville, an artist's world that combines the strong, compassionate simplicity of an outsider with an urban dweller's amusement at the surrounding life.

The African American faces he has done include a man with dark goatee, woeful eyes, a nose of protruding clay, and six-inch wooden cigar extending from his mouth, with trails of white tears beneath his eyes. *Queen of Niloville* features a regal woman, deep brown, with clear beads studded into the wooden surface, enhancing the aura of her crown. These takes on hardship and nobility, have masklike qualities.

"Most of my paintings are of country and religious things, from practical experience and sacred history," says Nilo.

Lanzas's code of morality is reflected in several interpretations of lower realms of the afterlife. In one picture, he places O. J. Simpson, Saddam Hussein, and Al Capone together in hell.

In another painting, *Welcome to Hell, Home of Homeless Souls,* Satan, all in black, dominates the fiery-orange arena where he is tormenting Lenin. In the next panel, Hitler is holding hands with Pancho Villa.

Pancho Villa? A guerrilla general of the Mexican Revolution who laid down arms in 1920, Villa was ruthless, but hardly a mass murderer like Hitler or a Bolshevik like Lenin for whom murder was a political tool. Why does Pancho Villa end up in hell with two certified criminals of history?

"Pancho Villa was the only man who invaded the United States," explains Nilo. "He went into Texas."

On a more uplifting note, he points to *Romance in the Gulf of Mexico,* with alligators kissing, mermaids kissing and fishes kissing.

Another picture has "Mermaid and Merman going South for winter," explains Nilo. He glances at another painting, of a man lying on the ground, training his gun on a snake. Then he turns to Mermaid and Merman, riding the fish, and murmurs, "Love is always better."

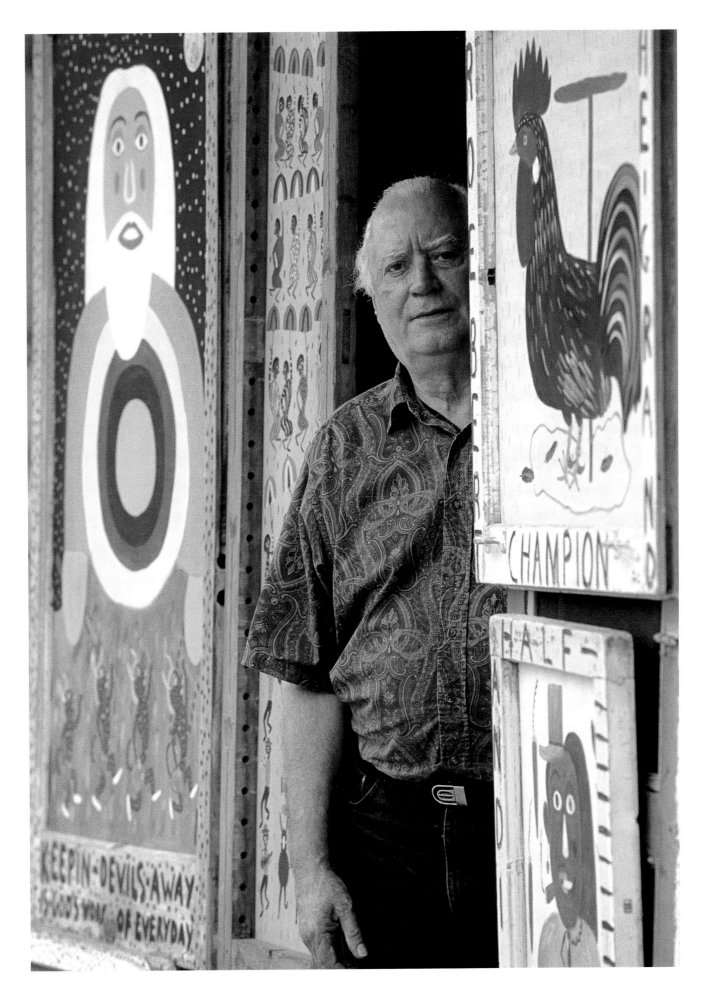

1999 Examples of his folk art frame Nilo Lanzas at his studio on Magazine Street in New Orleans.

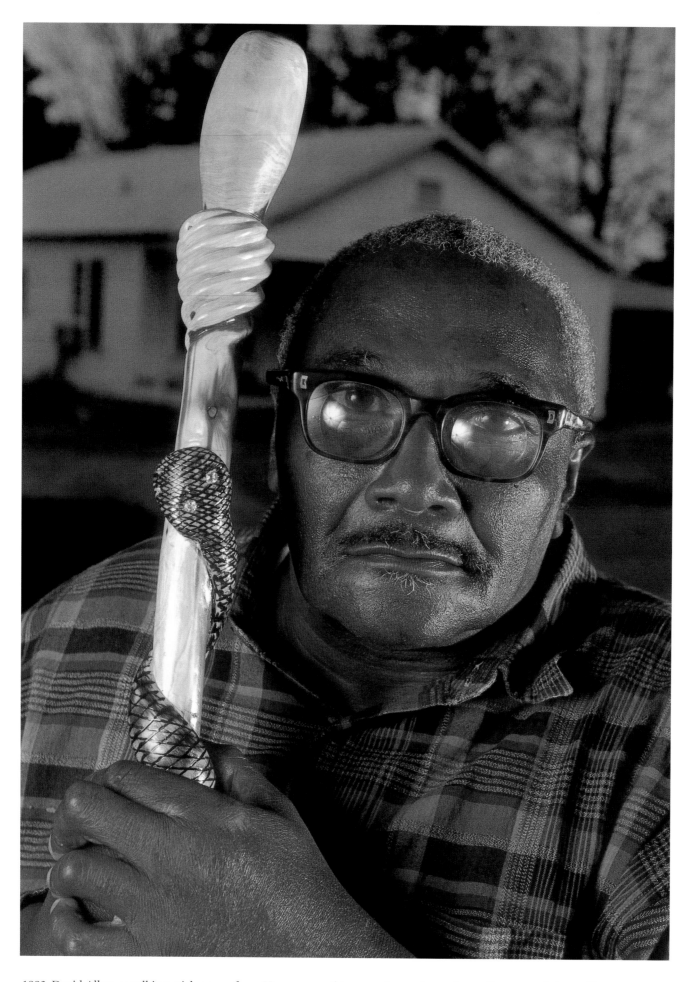

106 *1993* David Allen, a walking-stick carver from Homer, gave this one a decorative snake curling around the staff.

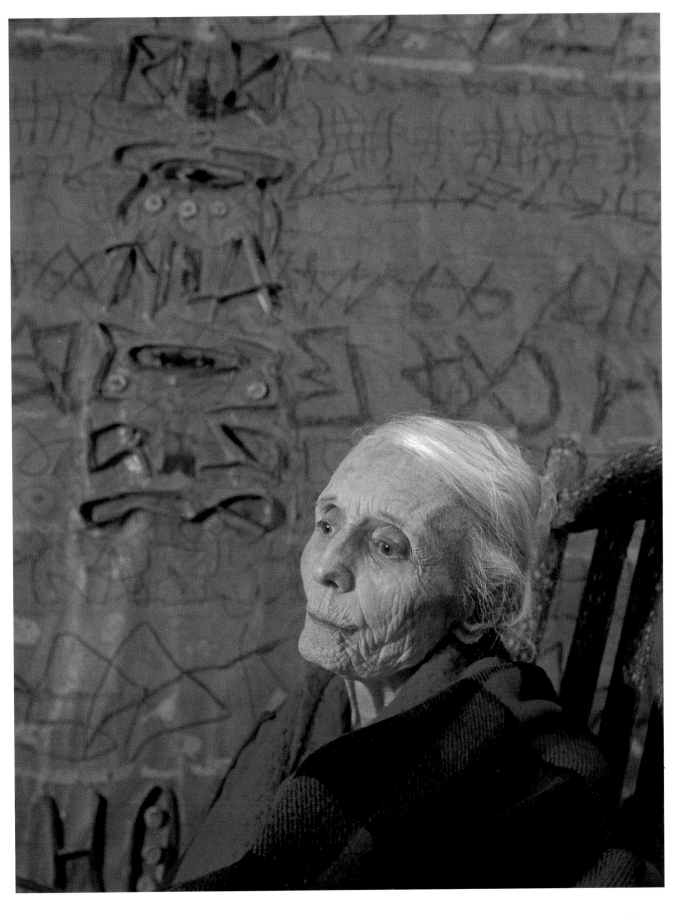

1993 Clyde Connell, an artist and sculptor, lived on Lake Bistineau, near Bossier City. Her much-praised *oeuvre* included religious figures on flat surfaces and small tower-shaped structures, bearing a haunting aura of prehistoric life. The earth tones and rough surfaces were influenced by the Louisiana landscape; her themes reflect baptismal immersions she saw in rivers as a child. She died in 1998 at age ninety-seven.

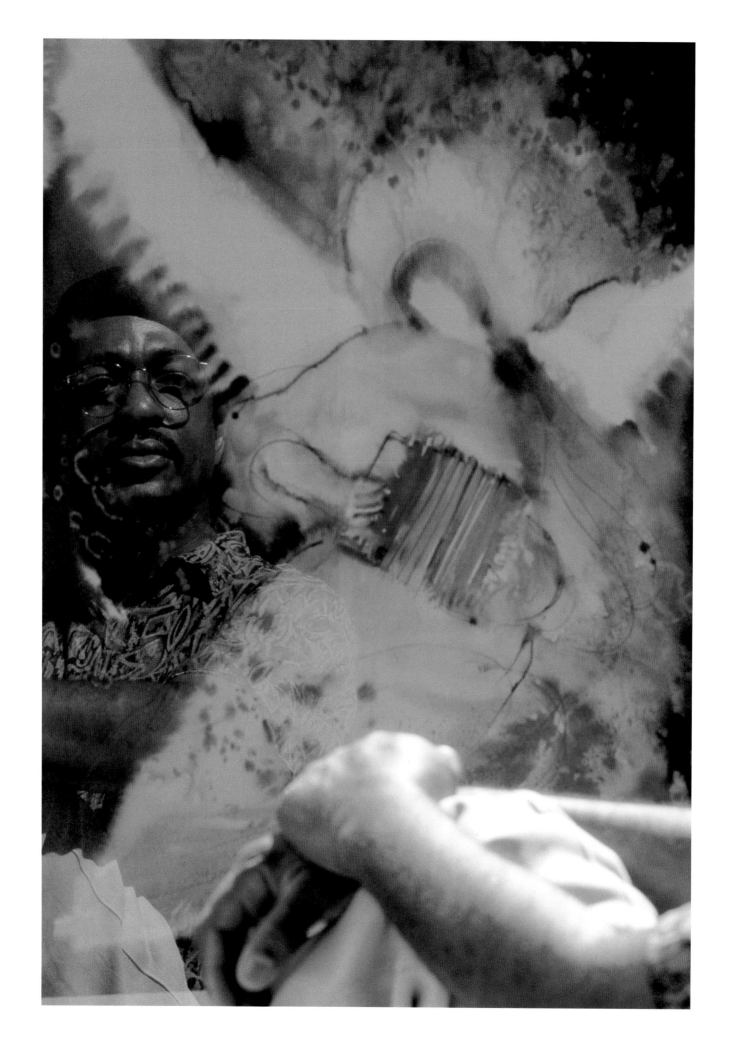

1999 Russell Whiting, sculptor, sits beneath the soaring wings of his *Icarus* in the sculpture garden of Joan McClure near Alexandria. Whiting is a self-taught artist who learned his vocation while serving a prison sentence in Louisiana. Later he refined his metallurgical techniques while welding on oil rigs. Whiting works spontaneously from dreams and fantasy. He is often surprised by the interpretations his pieces inspire but takes no credit. "My work is the ink spot," he claims. "The viewer is the patient and I have no idea where the doctor is."

1999 Dennis Paul Williams ponders his piece *Zydeco Angel*. As an artist, Williams specializes in "spirit works." He also plays jazz guitar with his brother, accordionist Nathan Williams, in the Zydeco Cha Chas band in St. Martinville.

1999 George Rodrigue poses with a friend and one of the artist's trademark Blue Dog paintings at his studio in Lafayette.

1999 Children's author, illustrator, and television animator William Joyce contemplates characters he has drawn on Easter eggs on his front lawn in Shreveport.

2000 The Kennedy family of artists with their home city of Monroe in the background. Glenn, left, is a muralist who painted this alligator, along with other species native to the Ouachita River, on a flood wall. Kim and Doug (both in blue) have colloborated on a series of children's books, including *Mr. Bumble*. Doug and John, right, have designed a line of apparel called Mojo Ware; it sells worldwide, especially in Japan.

1999 Muralist Robert Dafford paints the face of a Louisiana chef while his brother Peter works on another section of *Premier, Dernier, et Toujours* (*First, Last, and Always*) in Lafayette. The piece sums up the history of the people of rural south Louisiana and the status of the cultures there today. A lifelong resident of Acadiana, Dafford has painted more than 250 murals in a dozen states and in France, Belgium, and Canada.

1999 Renowned photographers of Louisiana swamps and wildlife, Julia Sims, C. C. Lockwood (center), and Greg Guirard scope a location in the Atchafalaya Basin. All three have worked diligently to document life in Louisiana's wetlands and raise public appreciation for the environment.

1999 Michael P. Smith with some of his photographs of Mardi Gras on exhibit at the Contemporary Arts Center in New Orleans. Smith is a pioneering documentarian of the local urban culture.

1999 Debbie Fleming Caffery adjusts her well-traveled camera in a field of burning sugarcane. Farmers burn the cut cane to remove leaves and debris from the stalks, which are not harmed by the process.

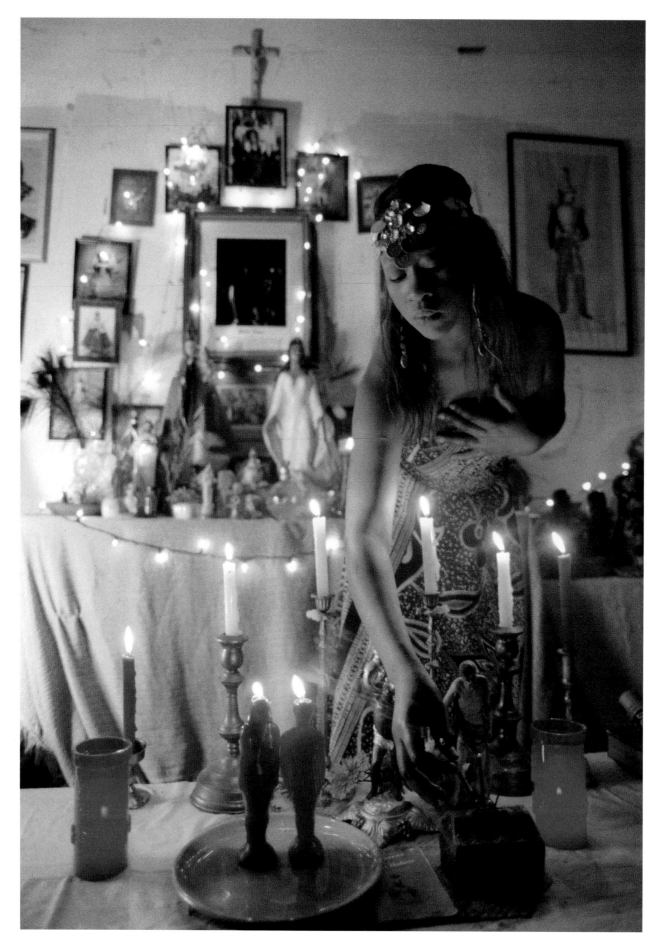

1991 Priestess Yaffa, a.k.a. Rose, lights candles before starting a Voodoo ceremony at her home in New Orleans's Marigny neighborhood.

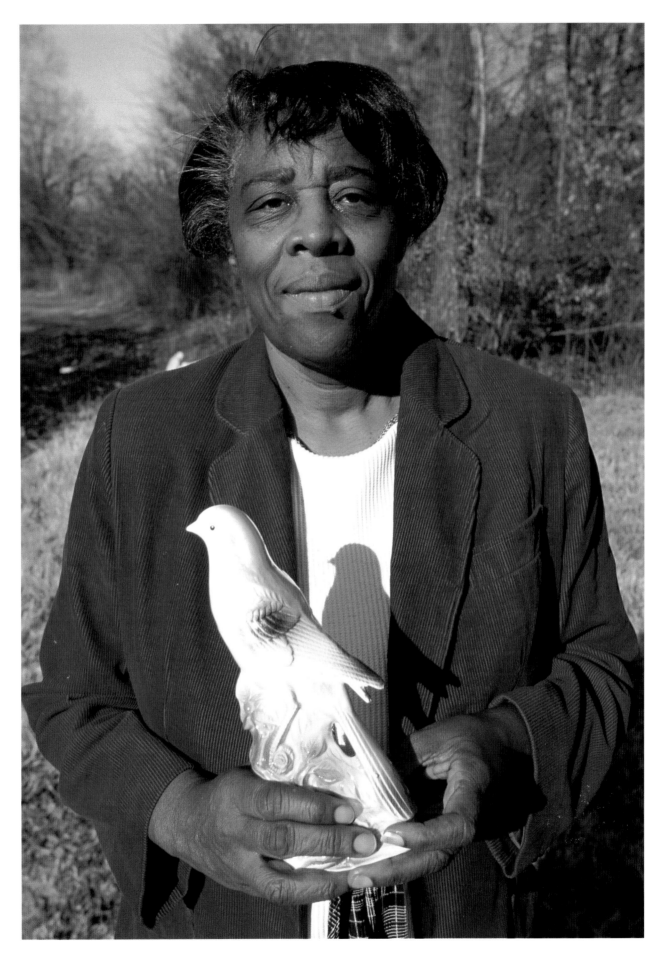

1999 Bertha Love holds a ceramic dove from a roadside flea market on Louisiana Highway 1 near her home in Rodessa, a small community north of Shreveport.

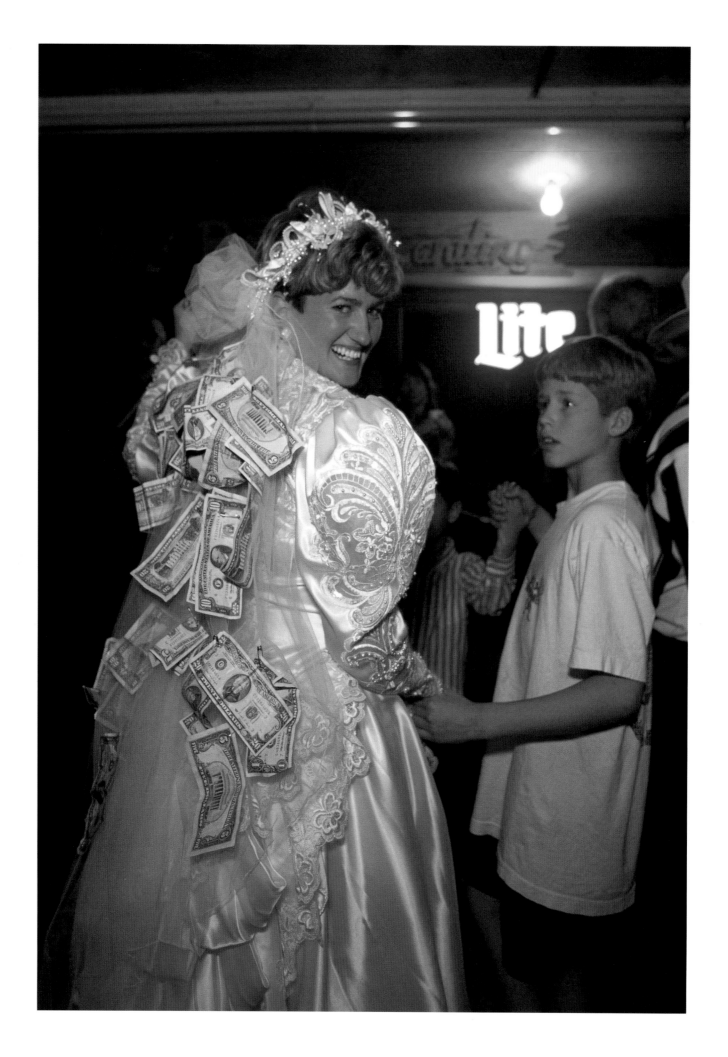

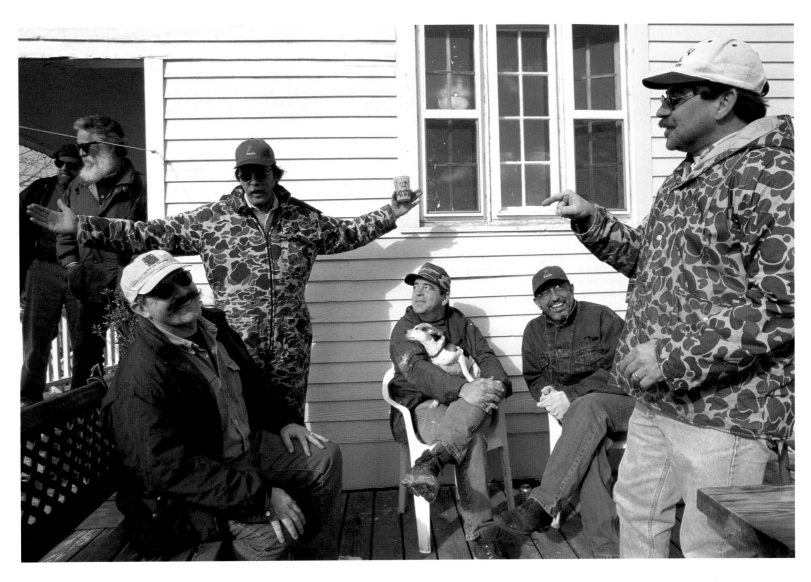

1999 Host Barry Ancelet stretches the truth as friends gather for an annual *cochon de lait* (suckling pig roast) party. Seated listening are two professional Cajun comedians, A. J. Smith (light hat) and Ralph Begnaud (red hat).

1995 Christine Balfa smiles at a wedding dance for her and groom Dirk Powell at Whiskey River Landing on the Atchafalaya Basin levee near Henderson. According to custom, people pin money on the bride and groom for the honor of a dance. The money goes to the honeymoon or household expenses. Christine and Dirk are members of the band Balfa Toujours. Her father was Cajun fiddler Dewey Balfa.

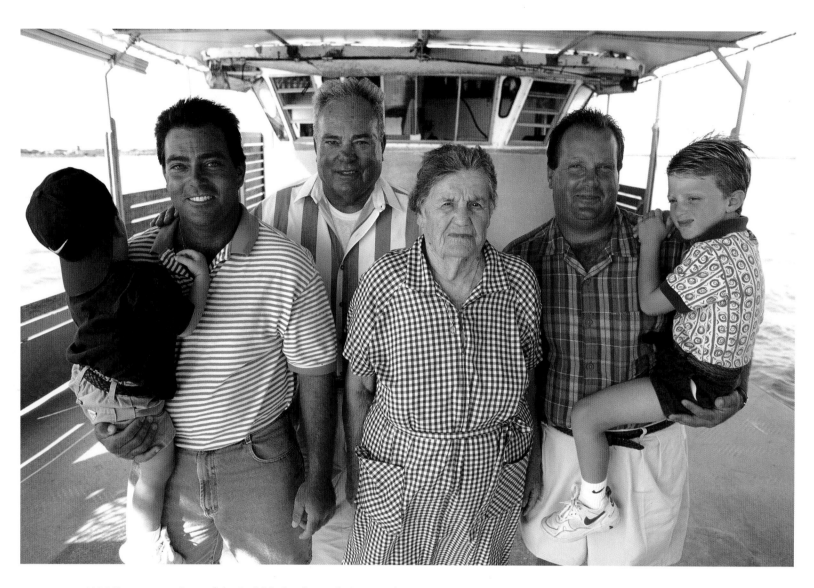

1996 Four generations of the Jurisich family on their oyster boat near Empire. The mother, Neda Jurisich, came to Louisiana from Croatia, in what was then Yugoslavia.

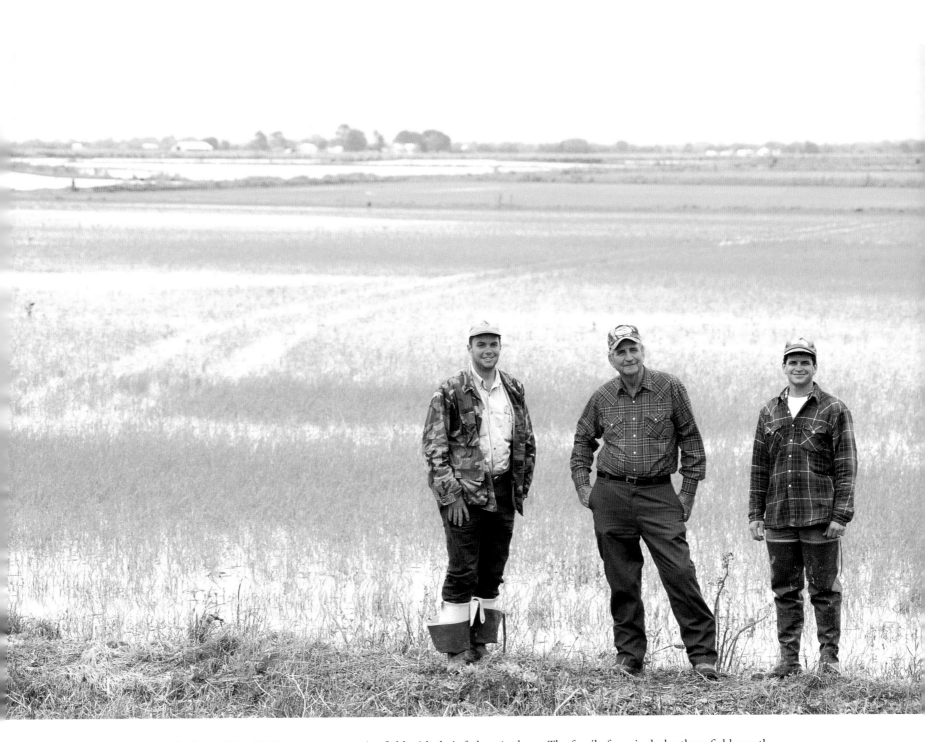

1997 Charles and Patrick Reiners survey a rice field with their father, Anthony. The family farm includes these fields northeast of Crowley.

1995 Clifford Champ (left) and Stan Jones connect length of drilling pipe on the Phillips Petroleum Sonat drilling rig in the Gulf of Mexico.

1995 Fred McFaddin, drilling superintendent of Shipshoal Rig No. 154 in the Gulf of Mexico, discusses operations over the phone.

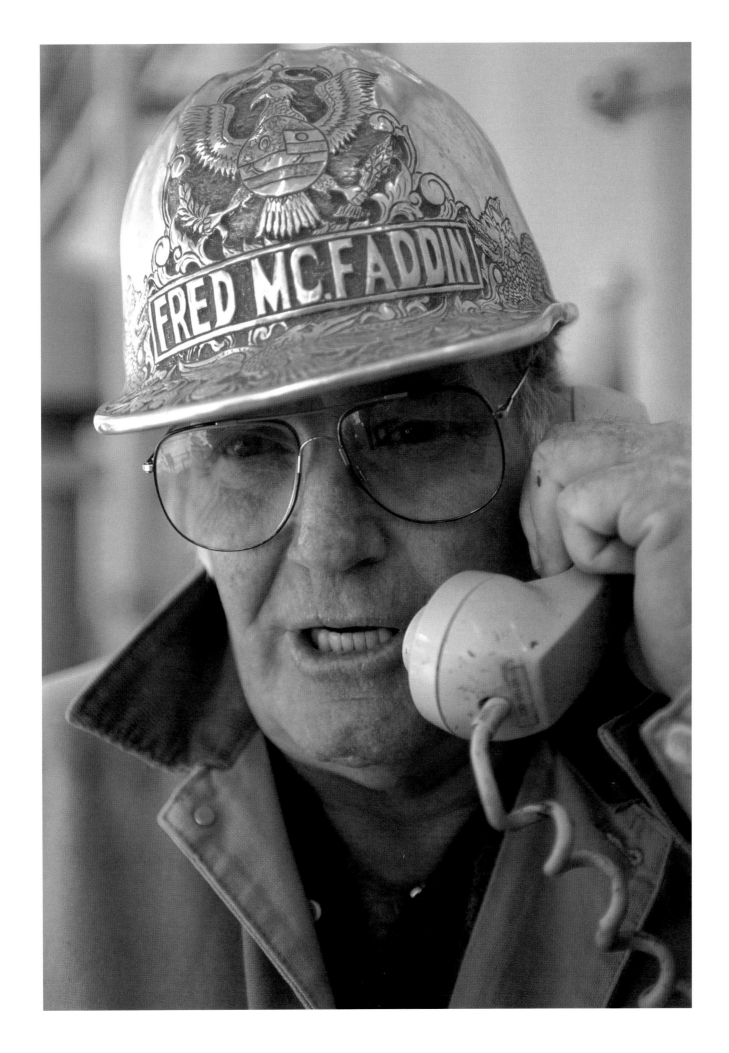

The Mardi Gras Indians—a tradition of African American masking, music, and street parading—dates to the 1880s. Donald Harrison launched the Guardians of the Flame in 1987 and brought his family into the ranks. The feathers, ostrich plumes, and sequins that make a successful Indian costume were like silk between his fingers. A waiter by profession for much of his life, he also helped his wife operate a day care center. A voracious reader, he once asked a friend, "You hip to Camus?" In an interview with the journal *Mesechabe,* he said: "For any art form (and I consider this an art form) to exist, there has to be a growth pattern, you see. The mode of dress has evolved so far from when I started masking that there would be no comparison with the Indians of today, who are young. They would laugh at what we wore! But they would miss an important concept . . . they are what they are today because we were the predecessors. We set a pattern and they improved it."

Donald Harrison died at age sixty-five on December 1, 1999, and was honored with a large jazz funeral. At the time of his death the Guardians of the Flame were releasing their CD *New Way Pocky-Way,* which features the old man's chants and singing. His son, alto saxophonist Donald Harrison Jr., is one of the finest jazz musicians of his generation. Donald Jr. appears on *Indian Blue,* with Dr. John on keyboard and the Chief featured on several cuts, leading chants from Indian lore.

1991 Donald Harrison Sr., Big Chief of Guardians of the Flame

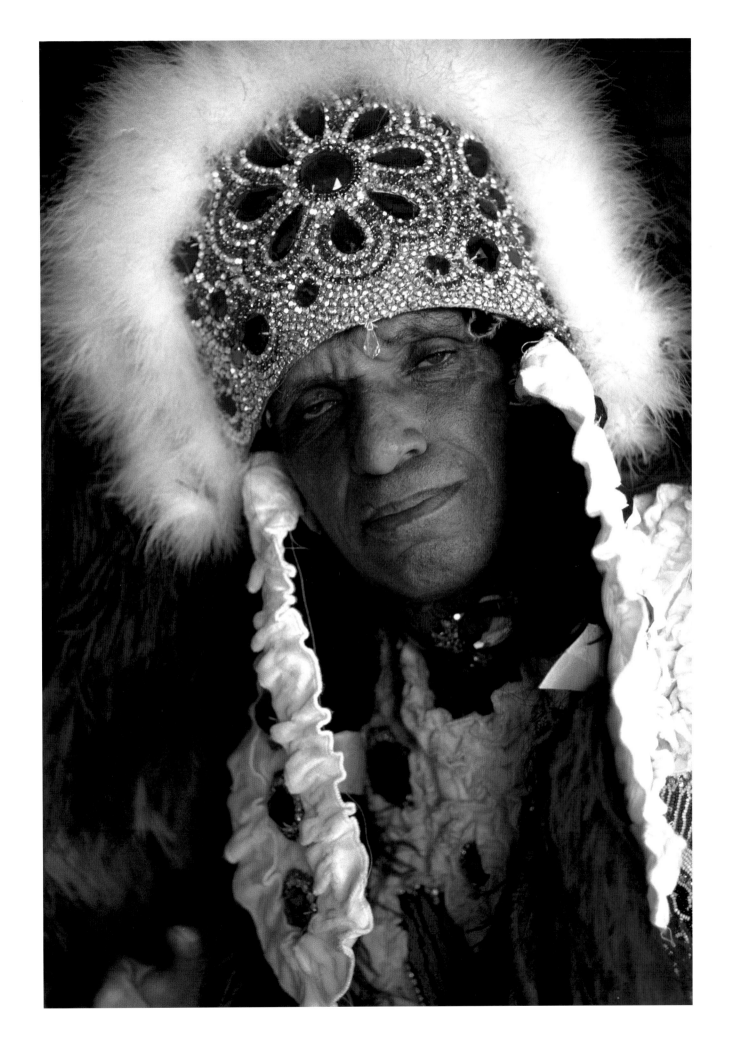

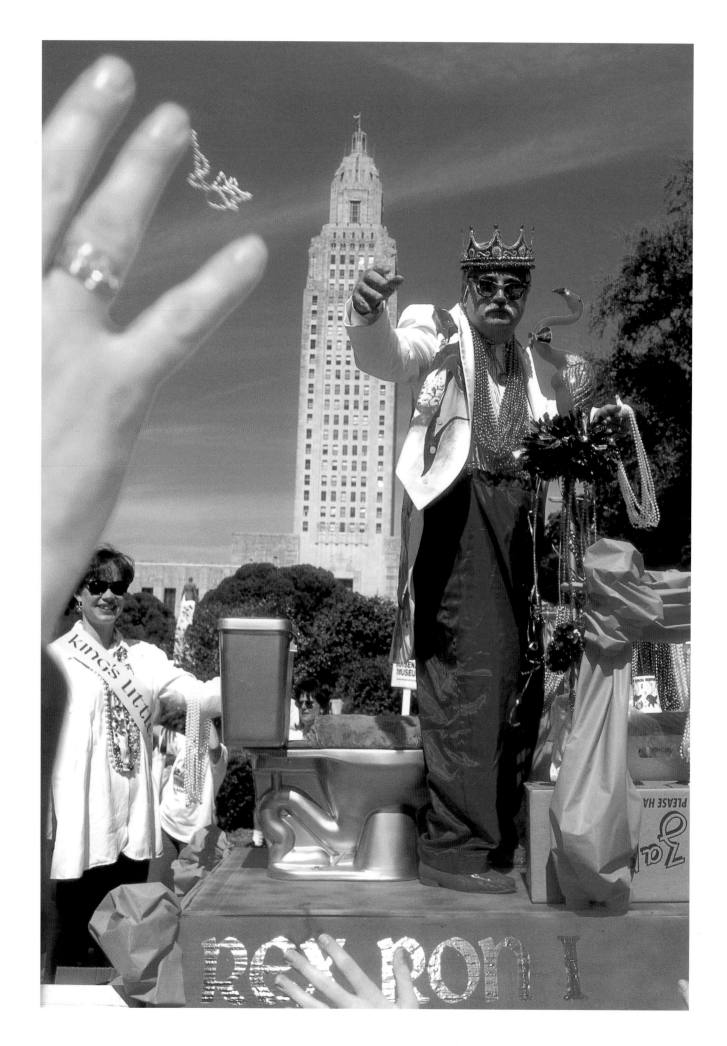

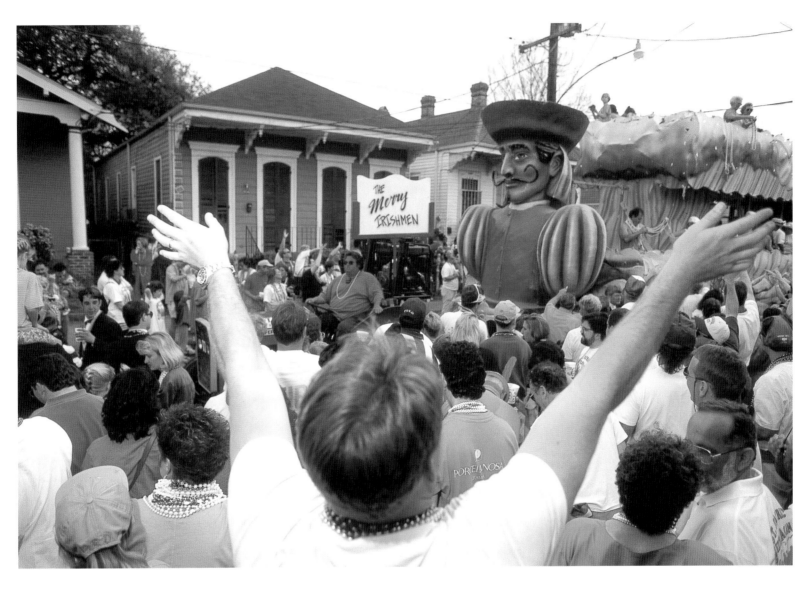

1996 A crowd cheers a Jean Lafitte float in the St. Patrick's Day parade, uptown New Orleans.

1994 Ron Zapp, king of Baton Rouge's Spanish Town Mardi Gras, throws beads from his "throne" as he passes in front of the State Capitol Building. On ordinary days Zapp heads the Zapp Potato Chip Company.

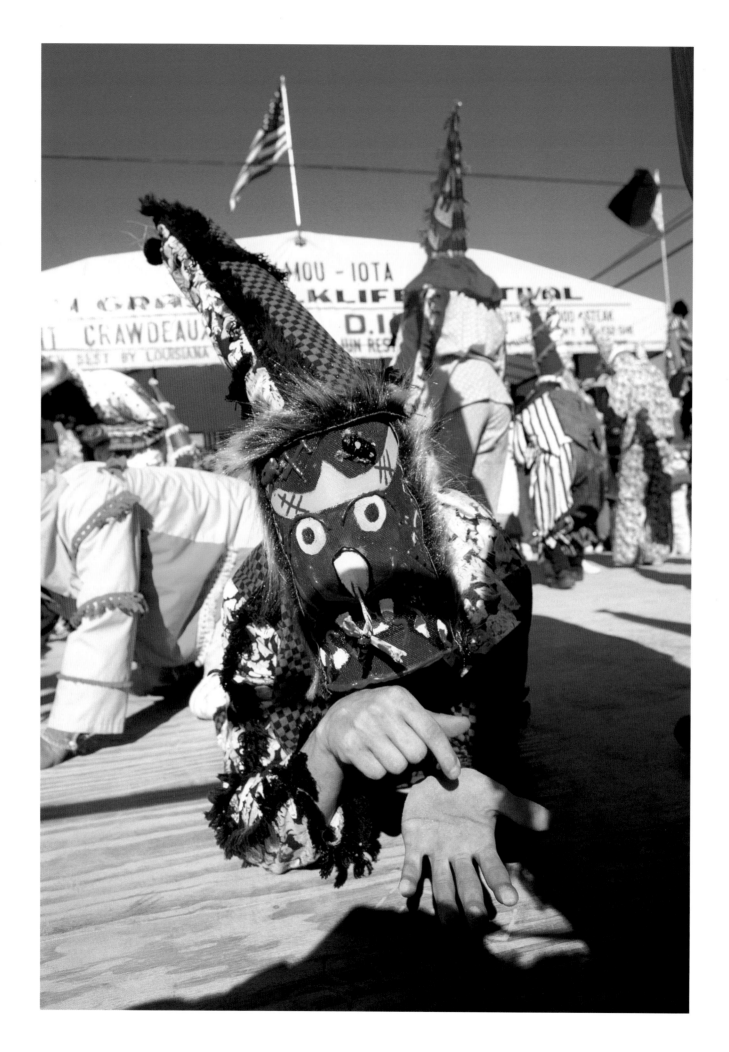

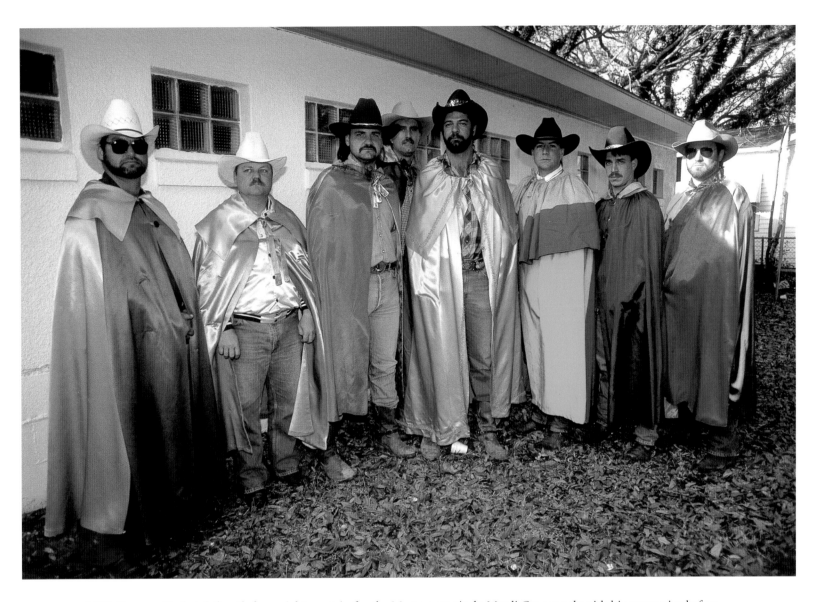

1990 Hannon Deshotel, fourth from right, captain for the Mamou courir du Mardi Gras stands with his cocaptains before departing on the annual run of horses, wagons, and celebrants in search of gumbo-destined chickens, good times, and—for first-time young riders—manhood.

1991 A Mardi Gras celebrant dressed in traditional costume makes the time-honored request for "cinq sous pour le Mardi Gras" (five cents for Mardi Gras) in Iota.

1994 Lane Leleux wears a chicken he caught during a courir du Mardi Gras in Hathaway.

1994 Thomas Deshotel holds his horse before starting the courir du Mardi Gras in Hathaway.

1997 Jason Livesay of the Krewe of Little Rascals rides in a Mardi Gras parade in Metairie. The krewe is for children exclusively.

1995 Kiki and Derek Huston, costumed for the day, engage in Mardi Gras love in New Orleans's French Quarter.

1997 King and queen of Carnival, Eli Tullis and Anne Ransdell Grace parade before their subjects at the 125th Krewe of Rex Ball ending Carnival season.

1989 "Nurses" pose during Mardi Gras in New Orleans.

Pointe Coupee Parish.

The cemetery lies a few miles behind the raised 1780s manor house of Riverlake Plantation, on False River, near the town of New Roads. The graves occupy a narrow grove nestled in wintry, listless fields of sugarcane. Shadowed by pecan trees, surrounded by vine-enmeshed bamboo stalks, some two dozen of the souls buried here are memorialized with headstones. Many more of those who worked as field hands or servants in the big house have no grave markers. Profusions of yellow wildflowers sprout from these sunken spots where the nameless dead, thanks to author Ernest J. Gaines, still have voices to be heard.

Born in 1933, Gaines grew up in the "quarters"—the small shacks, now abandoned, that were home to the black people who worked the land. Gaines has published seven novels and a collection of short stories, all set in Bayonne, the fictional counterpart for the community where he was born and raised.

The hold of this terrain on Gaines's imagination sets him apart from authors such as Toni Morrison and Charles Johnson, whose novels radiate a more eclectic, often spiritualist, sense of African American cultural memory. Gaines, like Faulkner, has grounded his characters in a small geographic setting that is a mirror on universal themes of "the human heart in conflict with itself." His breakthrough book, *The Autobiography of Miss Jane Pittman* (1971), was made into a popular film and has been translated into many languages. Since 1983 he has been writer-in-residence at the University of Louisiana at Lafayette.

The oldest of six children, Gaines was born when his mother was sixteen. Less than a week later she went back to work in the fields. His maternal aunt, Augusteen Jefferson, became the primary caretaker of Gaines and his younger siblings. This aunt, who would become the model for Miss Jane Pittman, was crippled. "She crawled over the floor like a child because that was the only way she could move," he explains. "She pushed herself over the ground to pick pecans. She washed our clothes and cooked our food. . . . Never once did I hear her complain about her condition.

As a boy Gaines helped his aunt and absorbed poetic rhythms of black speech patterns, mentally recording the lore of a people who forged cultural passageways out of hardship and struggle. He attended class five months a year in the small church that doubled as a schoolhouse. Matriculation stopped for seasonal planting and harvests. At age fifteen he moved to California to follow his mother, who had remarried and found better work out west. The day he left Louisiana, old and young people sat on Aunt Augusteen's porch, wishing him well. The old lady, whose majestic stoicism had taught him volumes about life, had tears in her eyes. In California he finally had access to a public library. But two years later, when his beloved aunt died, he could not afford a trip back for the funeral.

Now it is 1993, and in the milky sunlight of a February afternoon, we are standing in the cemetery, "the old place," as Gaines calls it. *A Lesson before Dying,* soon to be published, will win a National Book Critics Circle award, be featured by Oprah Winfrey on her television program, and be made into a film. This novel will also become a factor in Gaines's selection as a MacArthur Fellow. The success will help provide funds for his restoration project of the old community, putting it on the National Register of Historic Places.

The novelist points toward the road leading from the shacks to False River. "The privies [outhouses] were all in a row behind those trees," he says. "Every house had one on the ditch. My grandmother's house had a faucet on the road, and we'd go draw the water and bring it to the house. Those [faucets] weren't put down till the '40s. Before that it was wells: we'd draw the water in buckets."

Elderly women, grandmothers and aunts, play key roles in much of Gaines's work. As we stand in the country graveyard behind the big house, a line of birds flutters above and the sun drifts behind a cloud. Where, I ask, is his aunt Augusteen Jefferson buried?

"I don't know," he replies in a voice above a whisper.

Is he offended that this woman who meant so much to him lies in an unmarked grave?

"No," replies Ernest J. Gaines with tranquility. He gazes at the mosaic of yellow flowers. "She's there, still a part of me, with the others."

1993 Ernest Gaines at his boyhood church in Cherie Quarters

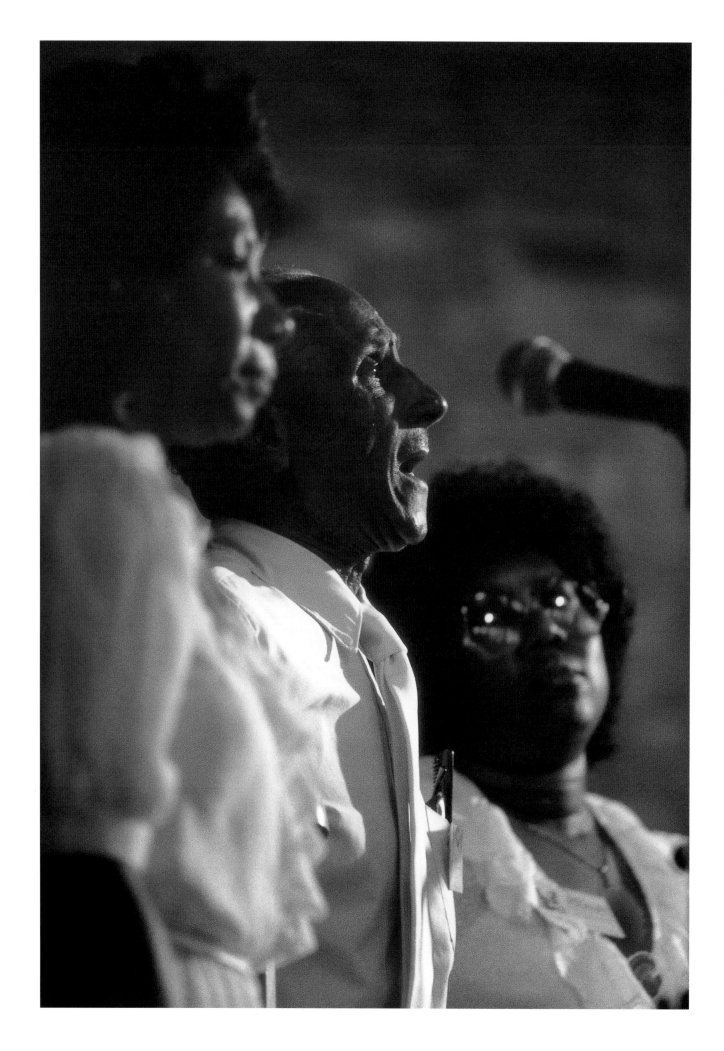

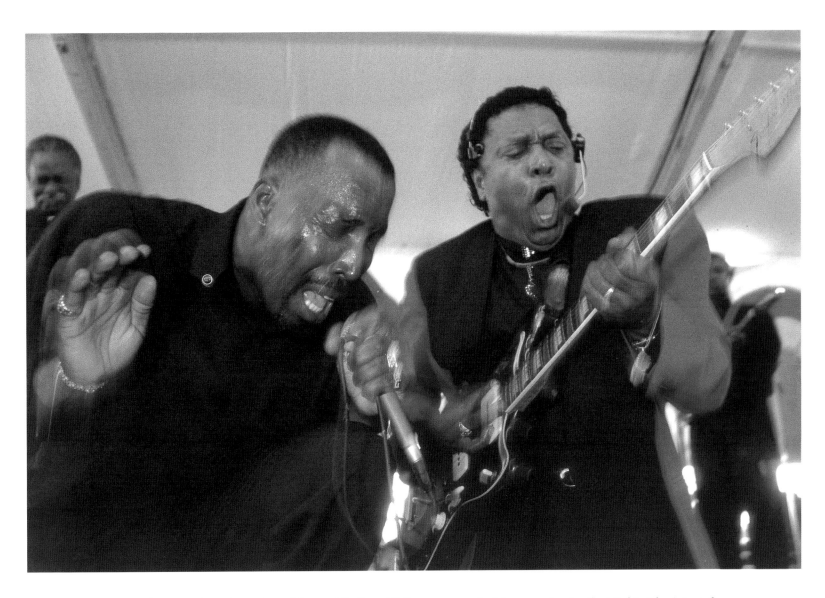

1997 Joseph Carter sings the praises of Jesus while Peter Walker accompanies him on guitar for the Mighty Chariots at the gospel tent during the New Orleans Jazz and Heritage Festival.

1984 The Williams Family Gospel Singers perform at the Folklife Pavilion of the 1984 New Orleans World's Fair.

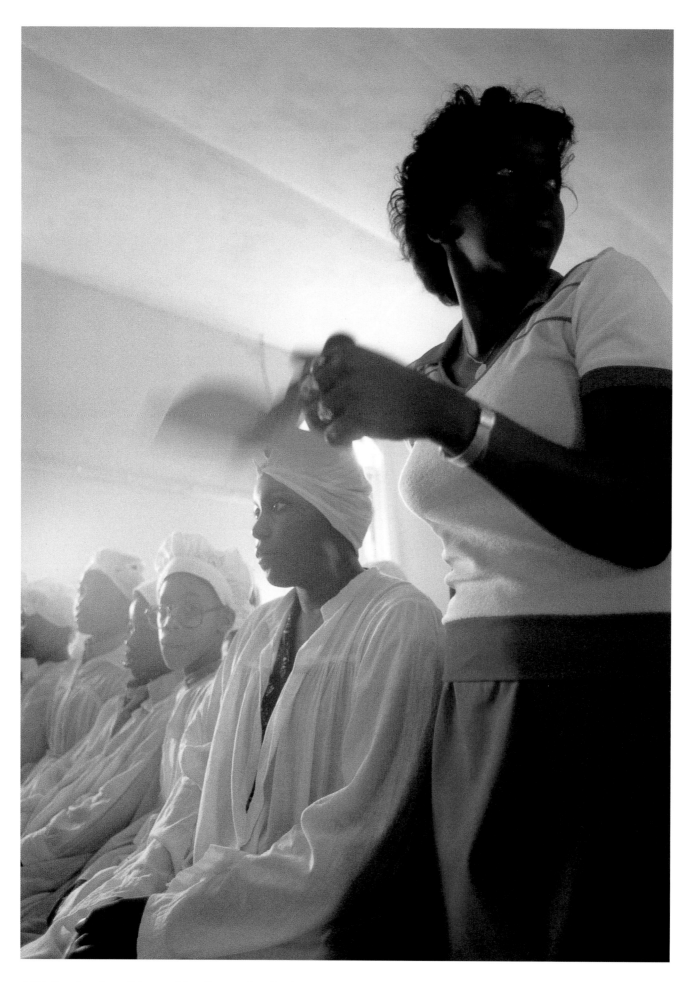

1981 Baptismal candidates at Newellton gather for the service that will precede their immersion.

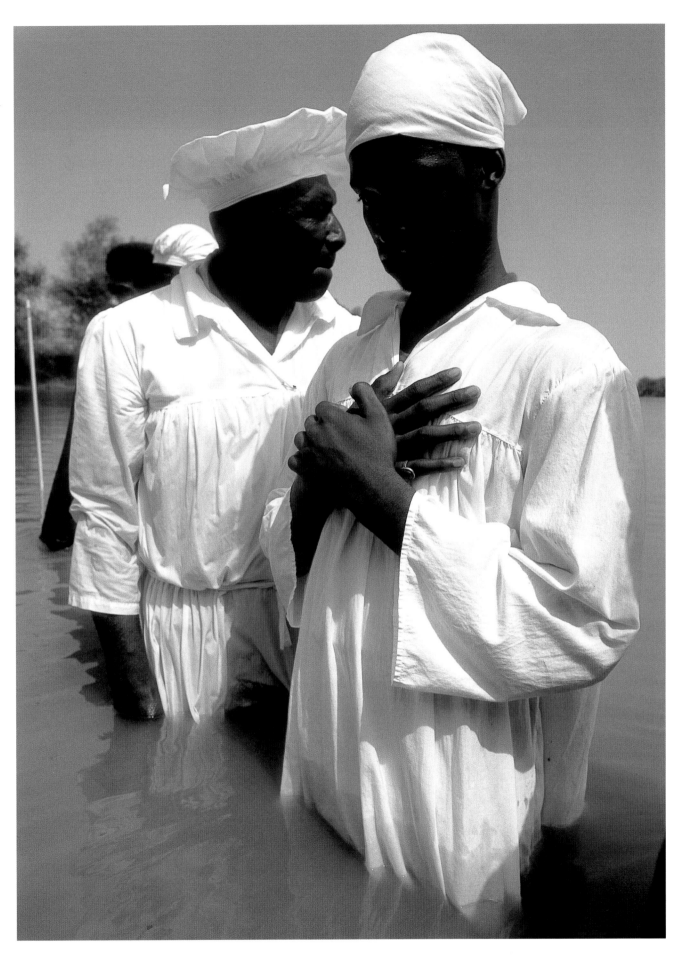

1981 Near Newellton a young man awaits baptism in a borrow pit, a pond made after earth was dug up to build levees along the Mississippi River.

1996 St. Joseph altar at the Marchese family home, New Orleans.

1996 The image of St. Patrick adorns a Fat Harry's ribbon on a tuxe-
doed celebrant of this popular Irish holiday in New Orleans. Fat
Harry's is a bar.

1984 Odeide Mouton was a sister of the Sacred Heart at the Academy in Grand Coteau. A native of Lafayette, Mouton taught at several Sacred Heart schools around the country and was head of both Maryville College in St. Louis and the Stone Ridge School in Washington, D.C. She retired to the convent at Grand Coteau, where she had attended school as a girl, graduating in 1921.

1996 In *Dead Man Walking,* her 1993 bestseller later made into an acclaimed film, Sister Helen Prejean reflected on the spiritual changes she underwent in opposing capital punishment. Raised in a devout middle-class home in Baton Rouge, she met men on death row through her work with the poor in New Orleans. In embracing an unpopular issue, Sister Helen became an unlikely celebrity. She now travels hundreds of days a year giving speeches, visiting prisoners, and lobbying lawmakers and criminal justice officials.

1999 Family members exit a church following a funeral service for a member of the Zulu Social Aid and Pleasure Club in New Orleans.

1997 A crown of icicles graces a statue of Jesus at the Academy of the Sacred Heart in Grand Coteau.

"A freeze had afflicted south Louisiana for a number of days when I went to Grand Coteau to photograph early that morning. I stopped at the Academy but found the gate shut. After wandering around for a bit with nothing photographic to show for my efforts, I walked back to my truck and noticed that the gate was now open. I saw no one else in the area. I walked into the grounds and came upon the iced statue." *Philip Gould*

1994 Former congresswoman Lindy Boggs (center) marches with family members during musician Danny Barker's jazz funeral in New Orleans.

1994 Grand marshals lead the Danny Barker funeral procession to St. Louis No. 2 Cemetery. Randy Mitchell, a neighborhood activist, holds the funeral program; on his left, in a white sash, is Babatunji Ahmed, a longtime presence in the jazz community. Both were friends of Mr. Barker.

1991 Beads and palm leaves encircle a portrait on a tomb in St. Louis No. 1 Cemetery in New Orleans.

1999 Photographs on a tomb in St. Louis No. 3 Cemetery serve as reminders of family members no longer living.

1998 A blind clarinetist, Jeffrey Diket, plays against a wall on Royal Street in the French Quarter.